50 GEMS OF

Hampshire

PETER KILBY

AMBERLEY

This book is dedicated to my family and wife Alice, who supported me on the many long journeys from our home in Gloucestershire, together with subsequent assistance from my sister-in-law Rosemary, who acted as my driver in East Hampshire.

First published 2021

Amberley Publishing
The Hill, Stroud
Gloucestershire, GL5 4EP

www.amberley-books.com

Copyright © Peter Kilby, 2021

Map contains Ordnance Survey data © Crown copyright and database right [2020]

The right of Peter Kilby to be identified as the Author
of this work has been asserted in accordance with the
Copyrights, Designs and Patents Act 1988.

British Library Cataloguing in Publication Data.
A catalogue record for this book is available from the British Library.

ISBN 978 1 4456 8491 8 (paperback)
ISBN 978 1 4456 8492 5 (ebook)

Typesetting by Aura Technology and Software Services, India.
Printed in Great Britain.

Contents

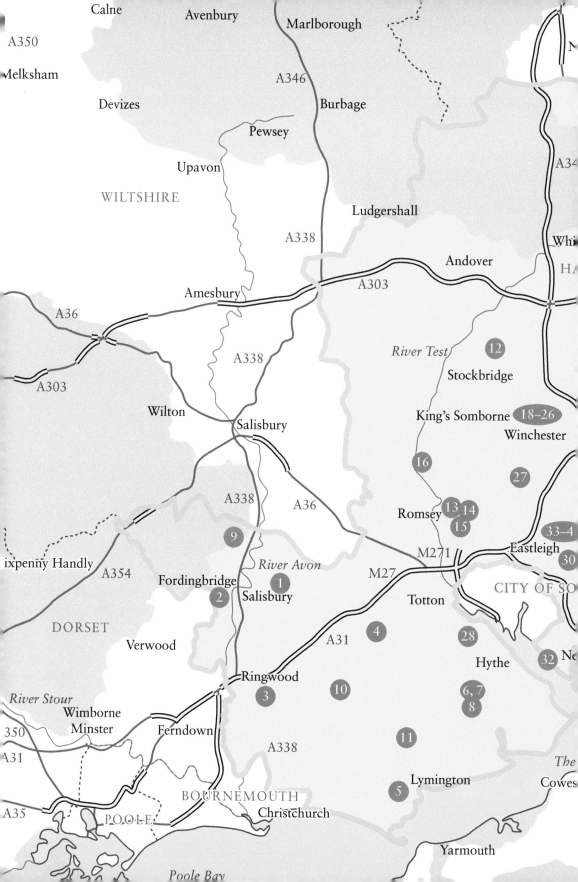

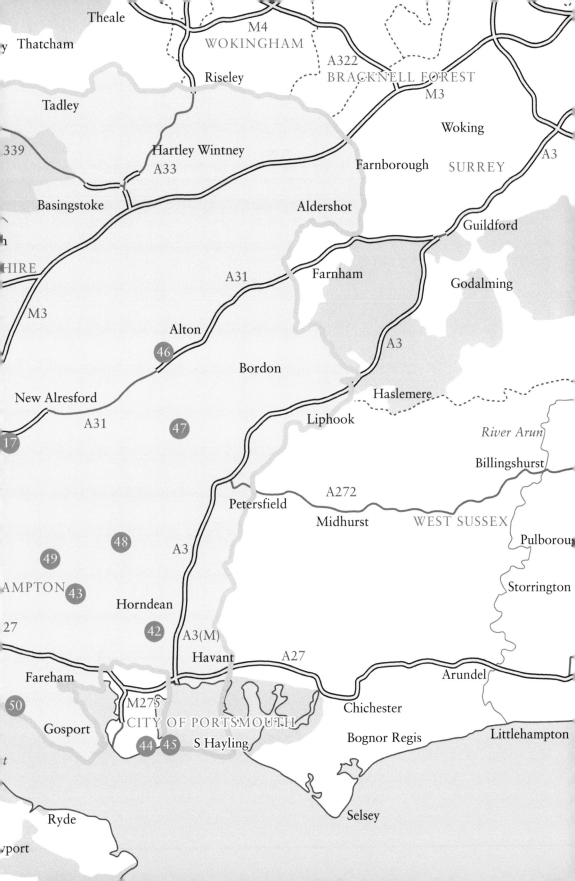

Introduction

Hampshire, which includes the Isle of Wight, is 'eighth in size among English counties' and, according to Pevsner's Guide, 'is a county with some of the finest scenery in the south of England, and remarkably varied, from the sandy heath of Surrey around Aldershot to the New Forest with its protected expanses of wood and heathland and the downs in the middle of the county, most unspoilt'. In addition, the most significant feature of the county is its seascapes, coastline and natural features.

The county has two large cities within it: Southampton, with its international container port and ocean-going cruise liners, and Portsmouth, home port for the British Navy. Southampton and Portsmouth are essentially medieval in origin, while Winchester was laid out by the Romans.

The early history of Hampshire is encapsulated in the Domesday Book of 1086, compiled on the orders of William I. Southampton has always been physically associated with the New Forest on its boundary with Southampton Water, and to the west the towns along the River Avon such as Breamore to the north, travelling south to Fordingbridge and Ringwood, the outpost of the forest. In the centre is Lyndhurst, the administrative centre, and Hythe, on Southampton Water, with its pier and passenger ferry to Southampton. The ancient town of Lymington, with its cobbled streets, is located on the south coast near to the ferry terminal, connecting it with Yarmouth on the Isle of Wight. Perhaps the most picturesque town is found nearby at Beaulieu (it has a stunning abbey), while nearby on the Beaulieu River is the village of Buckler's Hard, where some of the wooden ships of Nelson's navy were built.

Two rivers merge with Southampton Water: the River Test, passing through the town of Romsey, and River Itchen, which reaches the city of Winchester 10 miles or so northwards from its mouth. Southampton is characterised by the remains of its medieval walled town and the world-famous Bargate, where in 1415 Henry V addressed his troops en route to the Battle of Agincourt, and later in 1630 when the Pilgrim Fathers set sail in the *Mayflower* from the south of West Gate.

The city of Winchester was the see of Bishop William of Wykeham, who founded Winchester College in 1382. It is also home to the Hospital of St Cross, founded previously in 1136 by Henry de Blois, also Bishop of Winchester. These both represent the two major institutions of the city. The Cathedral Precinct and Close, lying as they do at the very heart of Winchester, bear witness to the ancient and ecclesiastical institutions within the city. Perhaps the most famous of the monuments within the cathedral is the chantry chapel of William of Wykeham (1366–1404). Ancient Winchester is today symbolised by the statue of Alfred, king of the West Saxons from 871 to 999.

Among his many achievements, he was instrumental in the preparation of the Anglo Saxon Chronicles.

Portsmouth is also a cathedral city. All mariners in port at any time and for the duration of their stay become parishioners of St Thomas' Cathedral – 'the Cathedral of the Sea'.

Like Southampton, Portsmouth is characterised by its defensive works of previous centuries, including naval and military buildings. Today it is also home of the iconic Spinnaker Tower on the waterfront, some 170 metres high with three viewing platforms, one with a glass floor. It is the centrepiece of Portsmouth Harbour's development, together with Portsmouth Harbour station and its ferry link to Fishbourne in the Isle of Wight.

There are major and minor transport links to support the outlying towns and villages of the county, including the M3 to London and M27 to Portsmouth. The more distant towns include Andover and Stockbridge to the north of the county and Aldershot to the east, with many other interesting places including Alresford, Bishops Waltham, Petersfield, Wickham and Horndean, for example. Eastleigh/Southampton Airport provides links with the Channel Islands and international services, while locally at Swanwick the National Air Control Centre is located. To add a piece of history, the prototype Spitfire, built in secret in Southampton and Woolston, was successfully flown in 1936 from then Eastleigh Airfield. It was piloted by Joseph 'Mutt' Summers. R. J. Mitchell, the designer of this amazing aircraft, lived locally in the quiet suburb of Portswood, Southampton, where a plaque on his former home records his achievements.

New Forest

Originally the New Forest comprised all land between the River Avon on the west, Wiltshire border on the north, the River Test and Southampton Water on the east, and the Solent to the south. Historically, this related to the general area of the New Forest created by William the Conqueror in the eleventh century as a royal hunting park. This caused the demolition of thirty-six parish churches and all houses belonging thereto, leaving the inhabitants homeless and without land. The general parameters of the New Forest are recorded in the Domesday Book as defining the 'Lands of the King'. It included Lyndhurst, the capital of the New Forest; Brockenhurst and Burley were the largest villages; and other settlements too, which all defined the overall extent of the New Forest then. Today there are the smaller areas. The national park is 219 square miles and the New Forest perambulations are 380 square miles. The New Forest is unique in that it is one of the largest tracts of unenclosed pasture land in south-east England. In addition, it was designated an area of Special Scientific Interest (SSE) in 1971, namely the 'New Forest Heritage Area'. In 1991 it was granted 'World Heritage Site' status by UNESCO. It is also a magnet for tourism – a fact not overlooked by both academic and business interests. The presence of ponies and cattle in the New Forest, which wander about unhindered, is without doubt one of the main attractions together with the often less visible deer of various breeds, which are usually seen among the trees inside the Forest 'enclosures'. The ponies and cattle, however, belong to the 'commoners', namely people who live and work in the New Forest who also have the rights to graze their animals on common pasture.

1 and 2. River Avon and Fordingbridge

Fordingbridge is situated on the far north-west corner of the New Forest on the banks of the River Avon. It was recorded in the Domesday Book and is a quiet historic market town today. The lord of the manor held a weekly market there from its establishment in 1273 until it was discontinued in the nineteenth century. The town is reached via an ancient seven-arch stone bridge, which is best seen from the Riverside Park and its lush green-water meadows. This bridge was first

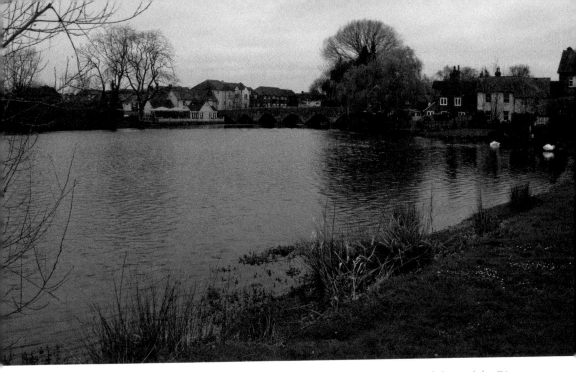

The graceful seven-arch historic stone town bridge seen against the backdrop of the River Avon and water meadows.

built in 1252 when the bailiffs and townsmen received a grant called 'Pontage' for repairs to its 40-metre span. Legend has it that up until 1840, during the time called 'Fence Month', a guard was mounted on the bridge to prevent venison from the New Forest being smuggled in. Once over the bridge the main streets of the town are at right angles to Fordingbridge, and parallel with the river. Being close to the river the town is no stranger to occasional flooding, but the waterside is central to its charm. It's here that the artist Augustus John is commemorated by a striking and powerful bronze statue alongside the bridge and riverbank, which is much in the character of this famous man. To the north of Fordingbridge town centre in Upper Burgate is the property known as Fryern Court, which contains the studio designed by C. Nicholson for Augustus John in 1932–34, but is now a private residence. On a road leading out of Fordingbridge is a public house called the Augustus John, which is full of memorabilia extolling the artist and his flamboyant lifestyle. Along the main streets of Fordingbridge traditional buildings on either side reflect the quiet character of the town and its people — it has a population of 6,000. Brick buildings with tiled or slated roofs predominate. Alongside these streets are little enclaves that are set back and in some cases lead back on to the river – its character pervades the town, creating an ever-changing visual scene. The Church of St Mary stands at the end of Church Street, with its east end and ancient churchyard similarly overlooking the fields leading down to the water meadows. The origins of the church go back to the twelfth century, although substantial rebuilding took place later in the next century, with walls in ironstone and Chilmark stone, followed by the addition of the lady chapel in the fifteenth century, with its wonderful hammer-beam roof and carved flying angels. The walls of the chancel show signs of settlement over the years. The church is a listed building and has some seventeenth- and eighteenth-century headstones in the churchyard. Each year on Mayday at 7 a.m., the church choir sing madrigals from the top of the tower to herald the beginning of summer.

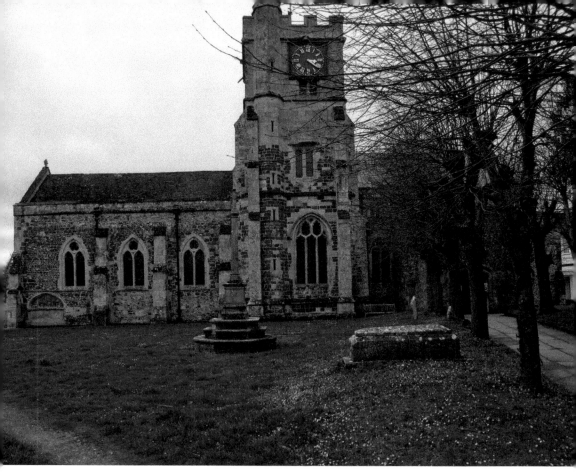

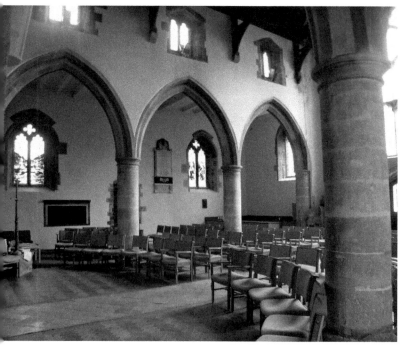

Above: St Mary's Church and Tower, where the choir sing madrigals from the rooftop on the first Sunday in May to herald summer.

Left: St Mary's Church nave where, following reordering, chairs have replaced pews inside the beautiful ancient medieval interior. (Courtesy of Revd Canon Gary Philbrick)

3. Ringwood

Further downstream on the River Avon lies the market town of Ringwood, an outpost of the New Forest. Unlike other places nearby, it is urban and bustling in character. There is a good deal of water around the centre of Ringwood, where the river flows beneath the elevated section of the A31 and under the Old Town Bridge at the far end of West Street, near to the appropriately named Fish Inn. Flowing away from the main river is the mill stream, running almost parallel with the High Street and fronted by an open area of land called the Bickerley Common, which is very picturesque but liable to flooding from time to time. The town centre is dominated by the beautiful Victorian Church of St Peter and St Paul, overlooking the Market Place and a landmark driving along the A31, particularly on the elevated section. This church, while being so close to a very busy road, is blessed with a quiet and serene interior – its stained-glass windows protect from the traffic outside. In March 1226 Henry III granted a weekly market in Ringwood on Wednesdays, which still occurs to this day between the hours of dawn to dusk for the sale of farm products and other wares from a proliferation of market stalls and good-humoured traders. All the basic needs of a weekly shop can be bought here. The market is cheek by jowl with the town shops, which usually occupy Market Place. On a warm summer's day one can experience an atmosphere here that encapsulates an era long gone, away from the paraphernalia of modern living.

Ringwood's old town's bridge in Water Meadows.

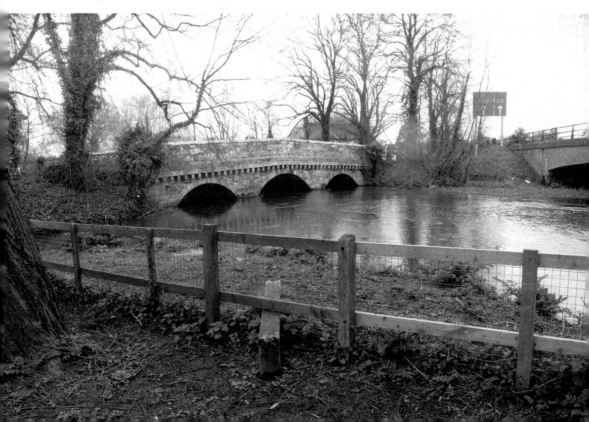

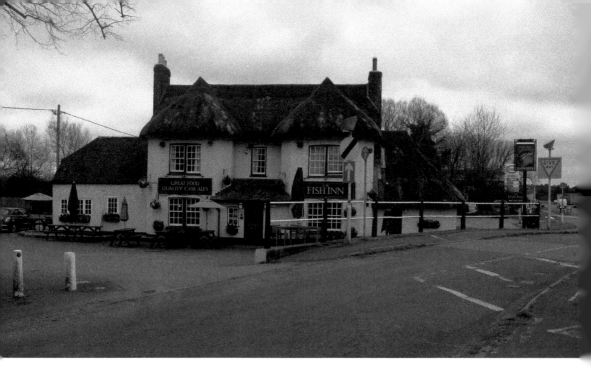

Above: Ringwood Fish Inn on the River Avon.

Below: Ringwood Parish Church overlooking the Market Place.

Above: River Avon at Fordingbridge.

Right: Ringwood's Victorian Church of St Peter & St Paul. (Courtesy of the vicar, Revd Trick)

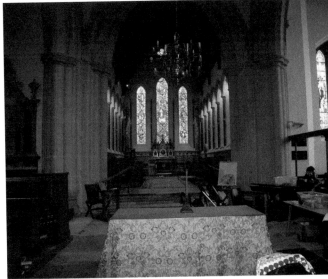

From West Street through to Market Place and beyond to the High Street, leading to Christchurch Road and out of the town centre, there is a rich heritage of buildings facing these roads. Many of these buildings are listed or of historic interest, and there are some remarkable hotels, like the Crown Inn at Friday's Cross and the White Hart Hotel in Market Place. The Town Hall, erected in 1868 when Ringwood was famous for the manufacture of woollen gloves, together with the Meeting House and the Old Town Bridge, are places of special interest. In summary, Ringwood is both unique and splendid and worthy of inclusion within Hampshire's gems.

4. Lyndhurst

The town of Lyndhurst, located centrally in the New Forest, is the administrative centre for both the verderers and the district council, and the national park. Its origins go back to the Domesday Book when there were administrative districts called 'hundreds', and today has a population of just 2,973. The Verderers' Court sits in the Queen's House, adjudicating on all matters relating to the management of the New Forest. In the 1200s Queen Eleanor of Castile lived; the property is now owned by the Forestry Commission. Lyndhurst has an unfortunate road system (which combines the busy A35 Southampton to Bournemouth roads). It passes through the town centre adjacent to the Crown Hotel where a T-junction interconnects with the M27 via the A 337, which also interconnects with the same road on the other side of the town leading to Brockenhurst. Over many years attempts to build a bypass have been frustrated by objections on environmental grounds; however, Lyndhurst remains a magnet for tourism and is well served by a large central car park, with the New Forest Reference Library and Museum and Visitors Centre sited there. One of the main attractions is the parish church of St Michael and All Angels, set on high ground in the centre of the town with a spire that can be seen for miles around. It was designed by the architect William White (1825–1900), who was a pupil of Gilbert Scott. Built from 1858 to 1869 in the high Victorian Gothic style, the interior

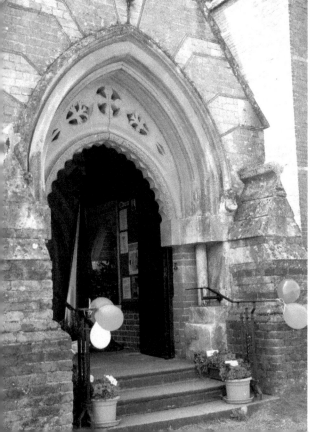

West door and ceremonial entrance of the Church of St Michael and All Angels.

of this church is extremely notable because it contains the work by some notable Pre-Raphaelite artists led by William Morris. Externally the north-west tower rises to a height of 141 feet. Once inside, the interior is equally impressive when viewed from the west door looking eastwards towards the chancel. The west doors, through which traditionally royal visitors to the Queen's House would enter the church, were donated by Chevalier de Chatelain in memory of his wife Clara, who is buried nearby. The approach to the chancel is made through beautiful iron gates leading to the high altar. On the east wall there is an impressive mural painted by Lord Frederic Leighton (1830–96) with the subject of the 'wise and foolish virgins', which was by all accounts carried out without charge, save the cost of materials, which were described as an example of a 'spirit fresco' using a formula devised by Thomas Gambier Perry to combat the effects of the British damp climate in a building without heating for the most part. Immediately above is the great east window, containing stained glass by Edward Burne-Jones, which together with Frederic Leighton's mural form a highlight of the memorable interior to this unique church. Outside the south transept and within the lush green churchyard lies the grave of Alice Hargreaves, who as a young girl formed the inspiration for Lewis Carroll's book *Alice's Adventures in Wonderland*. In addition, there is a dramatic zig-zag path to the east on the sloping lawns of the churchyard to deal with steep gradient, providing a more comfortable pedestrian approach from the lowest level.

Iconic reredos by Lord Leighton. (Courtesy of the church vicar)

Above: The church's spectacular nave vaulting. (Courtesy of the church vicar)

Below: South side location of the grave of Alice Hargreaves.

5. Lymington

The market town and seaport of Lymington was founded in the twelfth century by Richard de Redvers, Lord of the Isle of Wight, who was also responsible for founding Newport, the island's capital, together with the port and town of Yarmouth – all three places interconnected for trading purposes. The layout of the High Street in Lymington from its early foundation is one of narrow frontages of plots running back to lanes called burgages, these being ancient tenure lands in favour of the youngest son, but now fragmented. Today there is a mixture of two-, three- and four-storey houses and shops laid out almost higgledy-piggledy, but somehow charming. At the head of the High Street stands the Church of St Thomas with its distinctive tower and cupola, which, although medieval in origin, the inside is essentially Georgian in appearance with the addition of galleries and previously a three-tier pulpit, creating what has been called a preaching box. Today we see this church in its most recent incarnation, with modern seating replacing the pews into what is described as a place of 'flexibility, accessibility and beauty' – in other words reordering has taken place. At the lower end of Market Street a fantastic cobbled street winds down to

Parish Church of St Thomas – seen from the High Street.

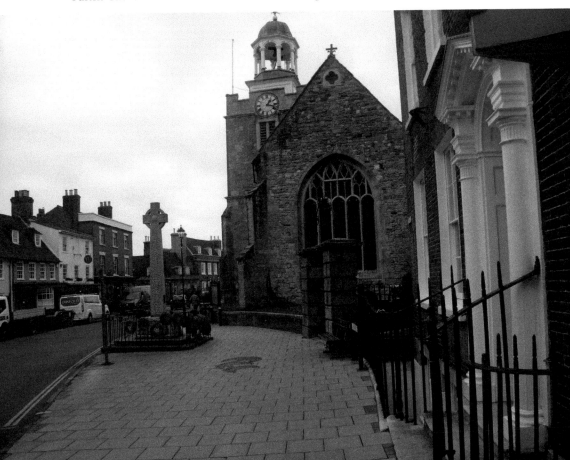

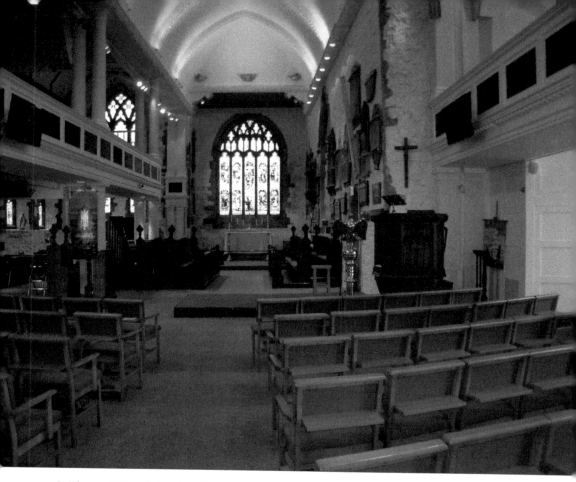

St Thomas' Church interior. (Courtesy of Revd Peter Salisbury)

the waterfront with the iconic Ship Inn and moorings for countless yachts and other vessels. Here we see the full expanse of the mouth of the Lymington River, with marshes on the far bank reaching up to high-watermark level and habitation beyond, together with the ferry terminal and ships sailing to and fro.

6 and 7. Beaulieu and Beaulieu Abbey

Beaulieu Abbey was founded by King John in 1204 for Cistercian monks, who took possession of the church in 1227 and dedicated it in 1246 to St Mary. This original church was built with stone from the quarries on the Isle of Wight, and Caen stone from Normandy was used for decoration and sculptures. Following the Dissolution of the Monasteries it survived in part with the *domus* (the monks' dormitory), cloisters and the original refectory, dedicated as the present Beaulieu Abbey, or Church of the Blessed Virgin and Holy Child, in 1538. Because of the previous use

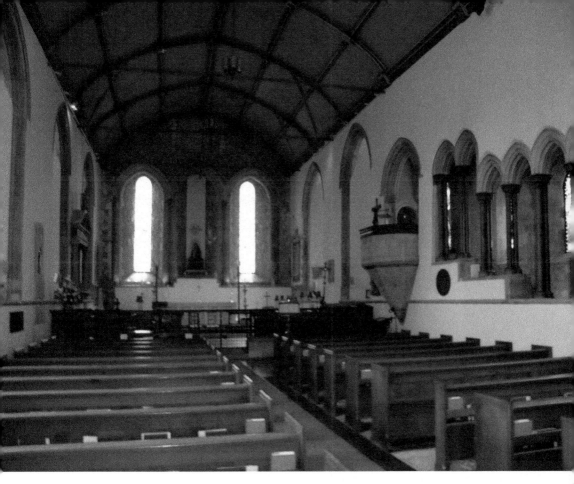

Above: Beaulieu Abbey Church interior. (Courtesy of the Beaulieu benefice administrator and Lord Montagu of Beaulieu)

Right: Beaulieu Abbey's beautiful Decorated-style windows.

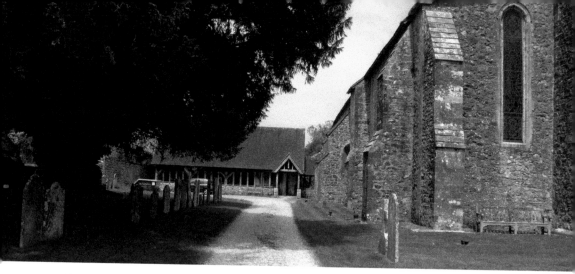

Above: Beaulieu Abbey and visitor's centre.

Below: Map of 1750 'Bewley' (Beaulieu), showing the Beaulieu River and Lymington Harbour. (Author's collection)

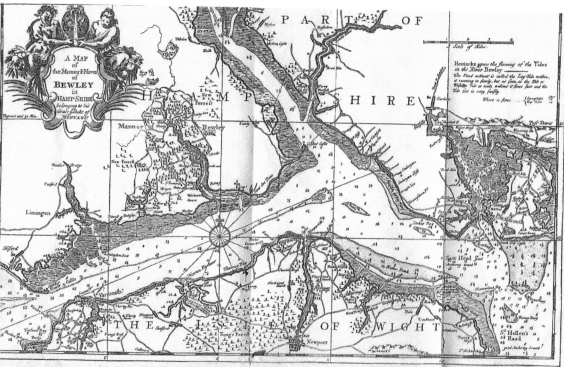

A MAP of the Manner & Haven of BEWLEY in HAMP-SHIRE belonging to his Grace ye Duke of MONTAGU.

THE River of *Bewley* is a safe Harbour, with Depth of Water sufficient to bring up Ships of almost any Burden as far as *Buckleyhard*, which two Miles from the Sea, where is a Convenient Key 100 Foot long, and Foot wide, the depth of Water being 18 Foot.

adjoyning to the Key there is a good Situation for a Town, upon a rising ound, gravelly Soil, with plenty of Fresh Water.

Bewley is situated between *Southampton* and *Lymington*, and is more Adragious for Trade than *London* or *Bristol*, by reason that Ships may Sail n this Harbour to the *Eastward*, with the same Winds that Ships may Bristol, with which they cannot Stir out of the River of *Thames*; to the *Northward* with the same Winds they may Sail from *London*, which they cannot Stir out of *Bristol*.

Bewley is distant from *Salisbury* 20 Miles, from *Winchester* 20 Miles, n *Ringwood* 16, from *Christ-Church* 16, from *Southampton* 5, from ington 5, from *Rumsey* 12, from *Fordingbridge* 16, from *Andover* 25, na, and Villages, in the *West of England*, that are now supplied with -*India* and other Foreign Commodities, either from *London*, or *Bristol*, be supplied with Sugars and all other Foreign Commodities, as well as n the Commodities of this Country, upon more reasonable Terms from

this Place than from any other, Considering there will be no Charges at this Port, and the Conveniency of Carriage from thence by Water, and Land, to all the Neighbouring Towns, upon the easy Terms following:

	per TUNN.		
	l.	*s.*	*d.*
TO CHICHESTER,	0	3	0
TO PORTSMOUTH,	0	2	0
TO SOUTHAMPTON,	0	1	0
TO REDBRIDGE,	0	1	6
TO NORTHAM,	0	1	6
TO BUSSELTON,	0	1	6
TO LYMINGTON,	0	1	0
TO EXCETER, PLYMOUTH, } and all the *Western* Coast to the Lands End, for	0	6	0

All these PLACES lie Convenient for Land Carriage to *Rumsey*, *Salisbury*, *Winchester*, *Waltham*, *Alresford*, &c.

There is great Conveniency for making Docks for Building Ships, and great Quantities of Timber growing on the Place fit for Ships or Houses, and Brick and Tiles made there at very reasonable Rates.

There is likewise a Market once in every Week, and two Fairs in every Year.

The Tenants of the Manor have Common without Stent, for their Cattle and Hogs, on the New Forest, with the right of cutting Turf there for their Firing.

They are also free from Toll, and Wharfage, &c. in all Ports throughout the King's Dominions, being ancient Demesnes by Grants of the Crown.

PROPOSALS.

FOR the greater Encouragement of Trade in the said Harbour, any Merchant, or other Person, that is willing to settle there, may, upon Application to his Grace the Duke of *Montagu*, have a grant of a Piece of Land, 170 feet in Depth, and 40 feet in Front, at the Yearly Ground Rent of six Shillings and Eight-pence only, and so proportionable according to a greater or lesser Quantity of feet in Front.

That every House may have a Close of Land belonging to it, in the Neighbourhood (if required) of two Acres, at the Yearly Rent of 13 *s.* and 4 *d.*

That the Front of all Houses be built entirely with Brick.

Three Loads of Oak-Timber will be allowed *Gratis*, for every House to be Built.

The aforesaid Grants to be made for 99 Years, if either of three Persons nominated shall so long live, without paying any Fine for the same.

This map was probably made about 1750, though the exact date is not ascertainable. It shows with accuracy the leading features of sea and land, which have not altered to any serious degree at the present date, March, 1909.

the church is orientated north to south instead of east to west, and the layout remains today. It has glazed doors on the north wall set in a lancet arch, leading out to the present Beaulieu estate. A staircase on the west wall leads to the original refectory lectern (now the church pulpit), while at the north end, set beneath the church wagon roof, is a gallery once used as the village school. In 1900/2 extensive archaeological excavations were carried out and detailed plans were prepared of the findings, including a plan of the present church.

8. Buckler's Hard

Buckler's Hard is one of the most important sites in the history of shipbuilding, owing much to the previous failed West Indies enterprise by John Duke of Montagu, who in 1722 had planned a new port here. Later, Henry Adams moved his shipbuilding business from Deptford in London to Buckler's Hard on the Beaulieu River, which

St Mary's Chapel, Buckler's Hard, previously a shipwright's house. (Courtesy of the Beaulieu benefice administrator and Lord Montagu of Beaulieu)

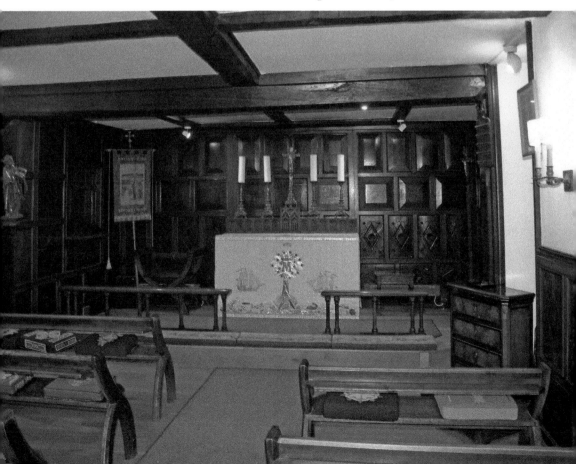

was a fortuitous move bearing in mind that to build one warship of average size timber from 2,000 oak trees was required, which was readily available on the estate. An ironworks was also close by at Sowley Pond, its great forge powered by a waterwheel. In addition with a tradition of shipbuilding in the area and an easily accessible harbour, which enjoyed all of the privileges of the Cinque Ports, this all engendered a hopeful future for the enterprise. Between 1743 and 1818 oak-built ships were launched here to support the British Navy during the Napoleonic Wars, including the Battle of Trafalgar. One of its most famous ships, the *Agamemnon*, launched in 1781, after which in 1783 Horatio Nelson was appointed her captain. Wishing to perpetuate his family name and to make Buckler's Hard a great seaport, Lord Montague renamed the town Montague Town. Henry Adams, the builder of so many ships at Buckler's, died at the age of ninety-two and is commemorated by a tablet in Beaulieu Church. The house nearest the river on the north side of the old street, home of the Adam family, stands today as testament to the history of the one-time illustrious shipyard and is now a hotel called the Master Builders House. Two lines of modest terraces of cottages line the open space of the old slipway, together with a fascinating museum full of drawings and maritime details. Opposite is the Chapel of the Blessed Virgin Mary, dedicated on 19 July 1935 by the Bishop of Winchester. The chapel is very small, one room in fact. It is part of the terrace of houses in the High Street – No. 82, originally a shipwrights house and formerly a school. There is a simple entrance with a single bell over the door (from Bonchurch on the Isle of Wight). The church guidebook states, 'The principal charm of St Mary's Chapel lies in its homeliness.'

Original shipwrights' houses either side of the Hard, where Nelson's ship the *Agamemnon* was built.

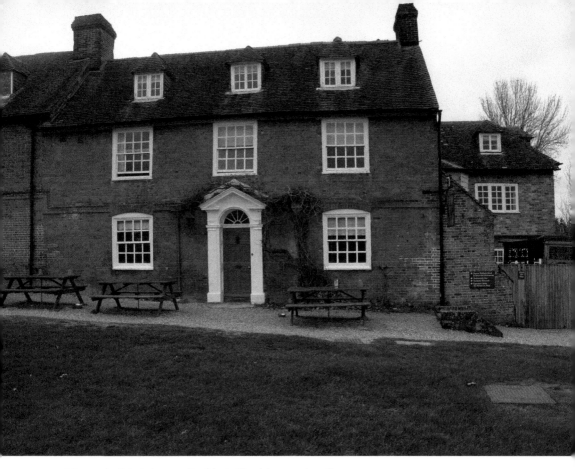

Master builder's house, Buckler's Hard (now a hotel).

9. Breamore

Other small villages of the New Forest include Breamore on the northern boundary with Wiltshire within the Avon Valley, together with Burley and Brockenhurst, both sited centrally in the forest enclaves.

The village of Breamore is for the most part unspoiled, and is remarkable for its ordinariness, with its quiet houses of mellow red brick and clay-tiled roofs nestling against the backdrop of the Breamore estate and its grand Elizabethan house. Beyond the village centre is an open green called The Marsh leading down to the village shops and the Salisbury to Ringwood road. Across this road lies the Village Hall and the Bat and Ball public house, completing this microcosm of the quintessential English village. Within this village lies the Saxon Church of St Mary, an architectural and historic jewel of a building set amid a slumbering churchyard framed by a statuesque yew tree. Dating from the tenth and eleventh centuries, the oldest part is thought to be a thousand years old. It has a squat central tower, flint walls (once plastered) and typical Saxon long-and-short work on its quoins. Internally the aisles, nave and chancel all combine seamlessly with the crossing of its tower. There is a minstrels'

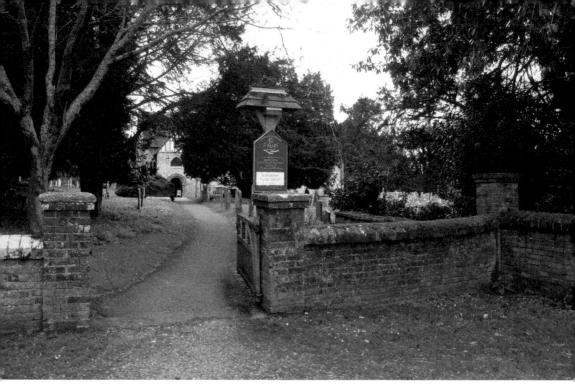

Above: Breamore Churchyard's entrance, with the church framed by majestic yew tree.

Below: The Saxon church at Breamore viewed from the east.

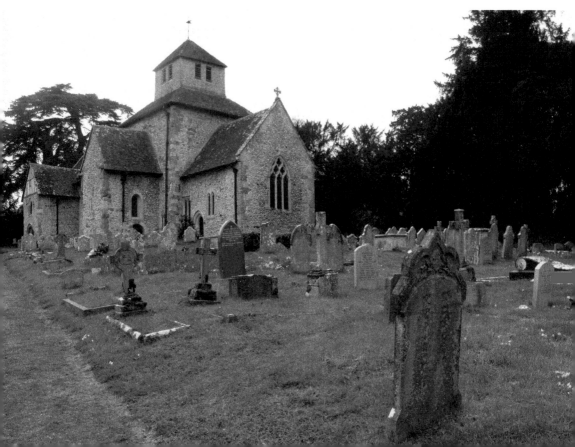

gallery to the west end, while to the east is a beautiful chancel arch incorporating rustic carvings of thistle, oak leaves and acorns. On the wall to the north aisle are traces of long-lost murals and, unusually, it is without windows and thought to have been so arranged to keep the Devil out.

The best view of Breamore House is from North Street where it is seen set among the rolling landscape of Breamore Park. This handsome red-brick and stone manor house was built by William Dodington and completed in 1583. Later, in 1748, the house was sold to Sir Edward Hulse MD, FRCP (1682–1759), who was a court physician and has remained in the Hulse family ever since. The house layout is in a typical Elizabethan E plan (three parallel wings extending outwards), with simple mullioned windows in all five gables, set in a tiled roof with tall brick chimney stacks at each end. In 1856 the house was severely damaged by fire and partly rebuilt in the aftermath, remaining as such today. Behind the house is a remarkable Victorian clock tower, built as a three-storey octagon and surmounted by a cupola, incorporating a clock, stables and supporting outbuildings. Beyond the house, around a mile away across Breamore Woods, is the mizmaze, cut into turf and chalk within a small surrounding coppice of yew trees. This maze is thought to be Saxon in origin and is designed in an intricate pattern, some 26 metres in diameter. Its use is uncertain, although other examples existing on other ancient priory sites such as Breamore are used as part of a meditation ritual by the monks.

Interior of Breamore Church with it spectacular organ loft and blank north wall. (Courtesy of Revd Canon Gary Philbrick)

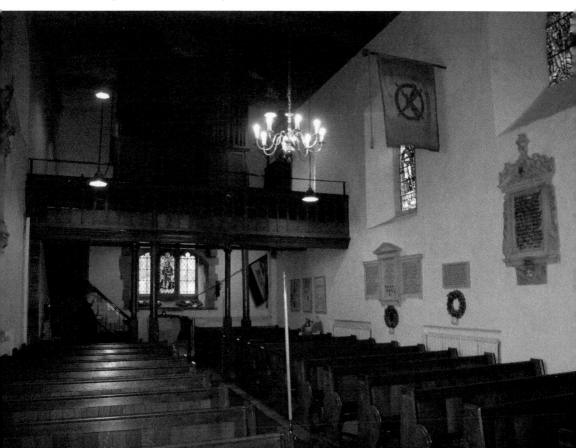

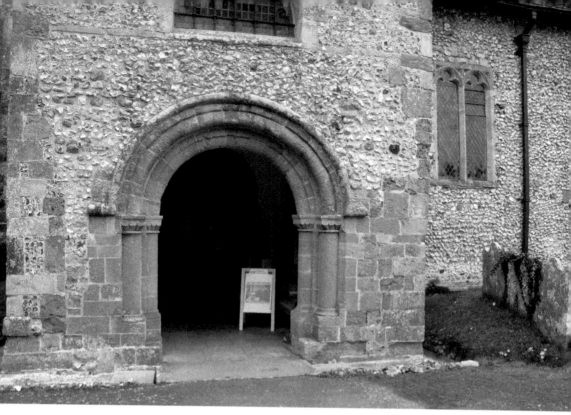

The entrance porch with typical Saxon long and short work at the quoins.

10. Burley

The village of Burley is mentioned in the Domesday Book and listed within the Ringwood hundred as being 'Lands of the King'. Today the village is in two interconnected parts, namely Burley and Burley Street. In 1847 it was linked to the railway system with the opening of Holmsley station (now tea rooms), and later after the sale of Burley Manor in 1899 developments began here. Situated on the extreme edge of the New Forest National Park and linked with the A31 to the north and Lyndhurst Road to the north-east, it is nevertheless quiet and remote, almost as if time has stood still, a place where forest ponies wander unconcernedly along its roads. Burley is primarily a tourist location, where one can explore its curio shops (like the Witches Coven) and its history of witchcraft and smuggling. One of its oldest cottages, in Burley Street, was once known as Police House and sits on the road frontage. It was sold off as part of the manor lands in 1894. It is possible there was an encroachment. This is because under forest law if a hearth and fireplace could be built between dawn and sunset a house could be built. This is borne out by the fact that the original house is single storey with a fireplace and walls built with cob, that is mud and straw, and originally a thatch roof. As a result the Crown owns all mineral rights beneath this property although it is now a private house. A small larder room originally had bars on the window when it served as the village lock-up.

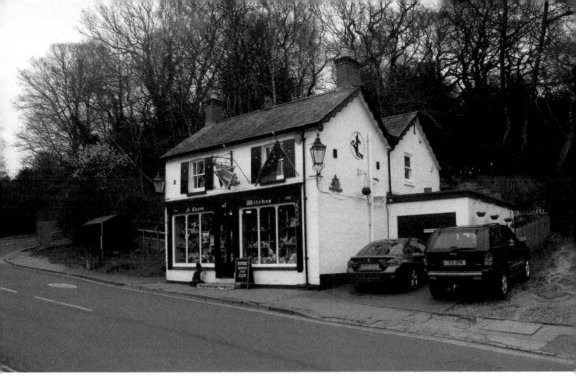

Above: This photograph of the famous 'Witches Coven' was once owned by a genuine 'witch', but today is just part of the ambience of the village shop.

Below: Photograph of the original police house where the present owners hold the right of 'commoners' entitled to a free supply of forest timber – now provided by the Forestry Commission.

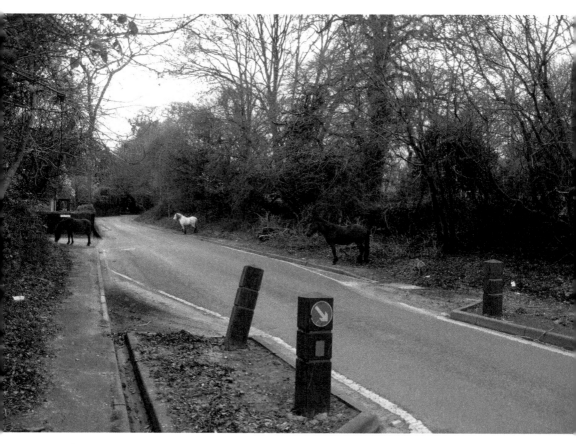

This picture shows New Forest ponies wandering on the road – all part of the ambience and character of the forest.

11. Brockenhurst

Like other villages in the county, Brockenhurst was also cited in the Domesday Book, this time in the Boldre hundred, which confirms its ancient history of 1,000 years. The coming of the railway in 1847 heralded a new era for a formerly quiet place, which today is host to a main line railway station linking Brockenhurst with both the south-west of England and central London. The main Brookley Road conjoins with the busy railway level crossing on the A337 Lymington and Lyndhurst Road, while at its upper end there is a ford crossing a watercourse called the weir, leading to the open enclaves of the New Forest. In other words, Brockenhurst is a place where town meets the countryside. Water is an important feature of Brockenhurst, with both the north and south weirs, which together with a second ford at Waters Green eventually join forces to merge with the Lymington River. To the north-east of Brockenhurst

is an idyllic place called Balmer Lawn where the Lymington River quietly ambles along; it is a spot greatly favoured by holidaymakers and their families during warm summer days. Historically this area was famous for charcoal burning, which was used in the manufacture of pottery from Roman times. Later it became known for the smelting of iron as well as the production of gunpowder – the latter two part of the maritime activities in the New Forest. The Church of St Saviour in Brockenhurst was designed and built by the architects Romain-Walker and Besant from 1895 to 1903. It was originally a private chapel for the Walker Munro family of Rhinefield, but was finally adopted as the parish church in 1922. This church is unusual in that it comprises a nave, aisles and chancel alone, and a south porch with grey stone walls from the Isle of Purbeck quarries. The crowning glory lies in the chancel, with beautiful Perpendicular stone galleries on the north and south sides approached by a spiral staircase, as noted by Pevsner and Lloyd who wrote 'the chancel with striking galleries the one distinguishes motif of the church'. Overall the church is a 'remarkable example of Victorian architecture' according to the church guide.

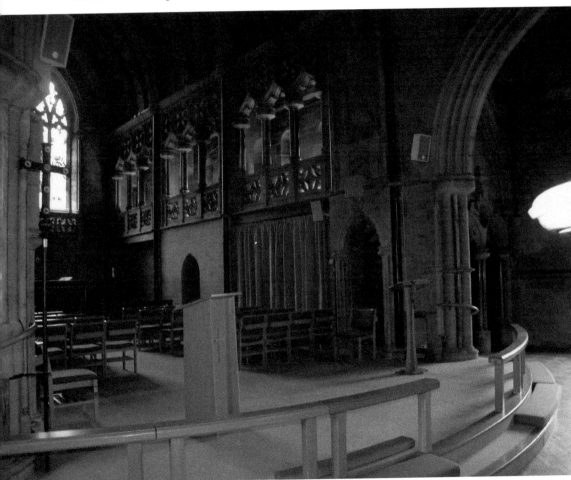

The majestic interior of St Saviour's Church. (Used with permission of the church vicar)

Romsey and the Test Valley

12. River Test

The River Test rises near to the village of Ashe in north Hampshire, near to Stevington where Jane Austen was born, and runs through chalk hills and downs. Its total length is 40 miles before it reaches Southampton Water in confluence with

To the south of Romsey, each year there is a fantastic display of blossom-bedecked trees running alongside the boundary walls of the Broadland estate.

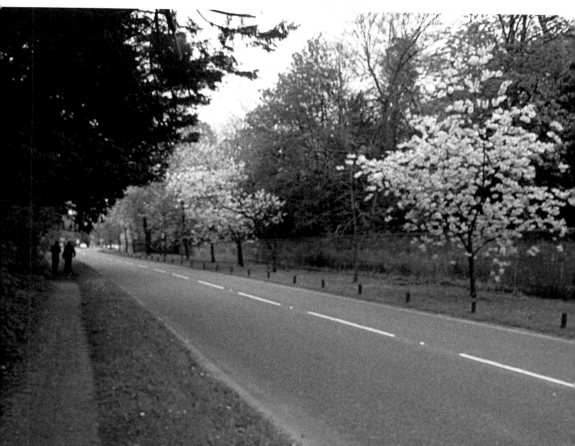

the River Itchen. This river is famous for trout fishing; that is, until Romsey as from then on salmon is also present in its clear waters. At Laverstoke, near Whitchurch, all paper for Bank of England currency was once made here in its paper mill, which is now a museum. This river gives its name to the local authority the Test Valley District Council and the statutory constituency of Southampton Test. From its source this river flows westwards towards Overton and the town of Whitchurch and through the village of Longparish, onwards to Stockbridge and the abbeys at Mottisfont and Romsey. Beyond this lays the Broadlands estate, formerly the home of Lord Palmerstone, remodelled by Capability Brown, and later Lord Mountbatten's home. It then arrives at the wetlands of Nursling, the Redbridge Causeway and finally Southampton Water. The River Test has been immortalised in literature by Richard Adams' iconic novel *Watership Down* with a hill in the north of Hampshire where the narrative takes place near to Kingsclear, just north of Ashe where Adams lived.

13. Romsey

The best view of Romsey is seen from the hill from Salisbury Road and the wooded Test Valley where the abbey stands out from its surrounding buildings and sits serenely alongside the beautiful River Test.

The River Test passes to the west of Romsey and, in close proximity to the west end of the abbey, south of Mill Lane. After passing under the Great Bridge to the north of the town the main river divides alongside the Mill Race, and, through Greatbridge Mill, spreads out until gathered in the mainstream when it passes under the A27 via the Middle Bridge in the south-west corner of Romsey. The river here shows its particular characteristics of splitting into a number of streams, but is both leisurely and quiet before meeting again. The presence of water in the centre of Romsey is in the form of secondary streams from the main river, in a network alongside streets and underground. It is one of its most endearing features, succinctly noted by Pevsner who wrote: 'Romsey is an Island, embraced by the River Test, divided into numerous braids.'

Up until the Dissolution of the Monasteries by Henry VIII, since it's foundation Romsey Abbey had been equal with Winchester as having one of the most leading nunneries in England. Romsey had prospered as a prominent market town, enjoying royal patronage. In the central triangular marketplace, permission was granted that allowed trade to be carried out there under a charter granted by Henry I. Later, in 1607, James I granted a royal charter confirming borough status with a Corporation and mayor, together with the creation of a court and court recorder. Throughout time the growth of the town centre has been curtailed by the river to the west and north and the large Broadlands estate to the south. On the outskirts of Romsey is the country estate of Embly Park, the previous home of Florence Nightingale, who laid the foundation of clinical nursing during the Crimean War after advising a sceptical establishment of her methods.

Abbey Water, Romsey, at sunset.

14. King John's House

In King John's House and Tudor Cottage, a Grade I listed building, is a surviving medieval lodge, thought to have been used as a base for hunting deer in the New Forest. Close by the east end of the abbey there is a beautiful enclosed garden, behind which one such stream is located at its end. The Domesday Book highlights the presence of mills in Romsey, which over the years played an important role in the history and industries of the town, including the woollen trade, when power from its watermills carried out the fulling process, washing and dyeing prior to exporting the finished product to the continent via the nearby port of Southampton. Following the decline in the eighteenth century, wool was surpassed by the new industries of paper making, sackcloth and brewing – all related to the plentiful supply of clean water from the River Test.

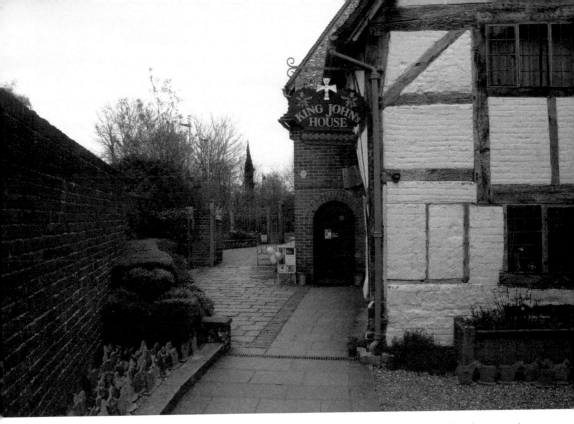

Above: King John's House, built originally as a hunting lodge with a timber frame and oak roof with Tudor king posts – now a museum.

Below: This garden is bounded at its end by a burbling watercourse, seen against the serenity of the flower beds.

15. Romsey Abbey

Romsey Abbey was founded in 907 by Edward the Elder for his daughter Elfleda. A second foundation came in 967 and the rebuilding of the abbey began in 1120 and continued into the end of the twelfth century (following Viking raids of 994, which had ravaged Romsey). The stone used came from the Isle of Wight as ballast in ships to create this beautiful abbey, which when complete some was 256 feet long according to Pevsner and Lloyd. It continued caring for the needs and spiritual life of the town until its dissolution in the fifteenth century, similar to nearby Mottisfont Abbey. However, Romsey itself was purchased from the Crown in 1544 for £100 and the abbey became the parish church, one of the largest in England, and most importantly the nuns were able to share the same building and continue with their ministry. A reminder today is the 'Abbess Door' in the south aisle of the nave where a splendid tapestry curtain, embroidered by students of the Southampton College of Art, defines the place, with access to the previous abbey cloisters. At the crossing beneath the central tower a fine Jacobean ceiling was installed as the floor to a new ringing chamber for the bells, which had previously been in a detached bell tower. In the south transept is the grave of Lord Mountbatten, formerly residing in the nearby Broadlands estate who died an early and tragic death in 1967 while on holiday in Ireland.

Romsey Abbey's east end in a Norman style.

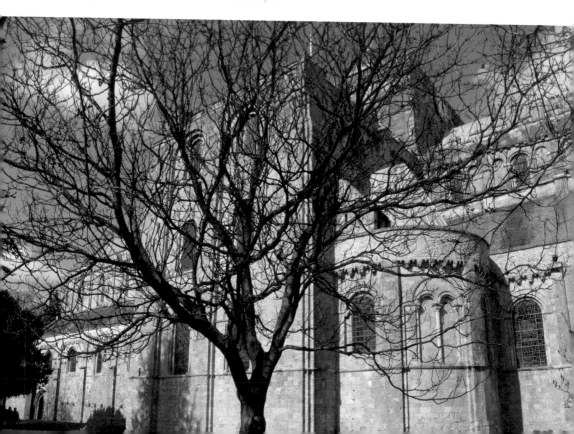

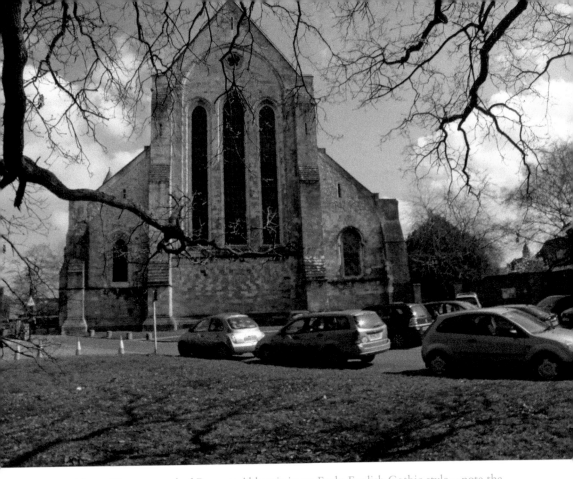

Above: The west end of Romsey Abbey is in an Early English Gothic style – note the pointed arches over the windows.

Below left: North-west porch and door.

Below right: North aisle. (Reproduced by the kind permission of Revd Thomas Wharton, vicar of Romsey Abbey)

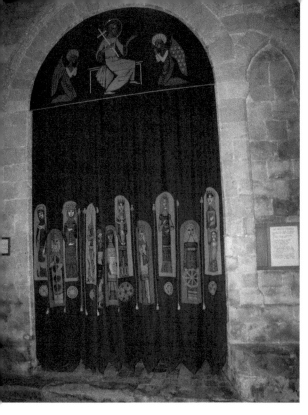

Left: Detail of beautiful tapestry curtain embroidered by students of Southampton College of Art. (Reproduced by the kind permission of Revd Thomas Wharton, vicar of Romsey Abbey)

Below: A dramatic view of painted woodwork on the ceiling of the ringing chamber in the tower. (Reproduced by the kind permission of Revd Thomas Wharton, vicar of Romsey Abbey)

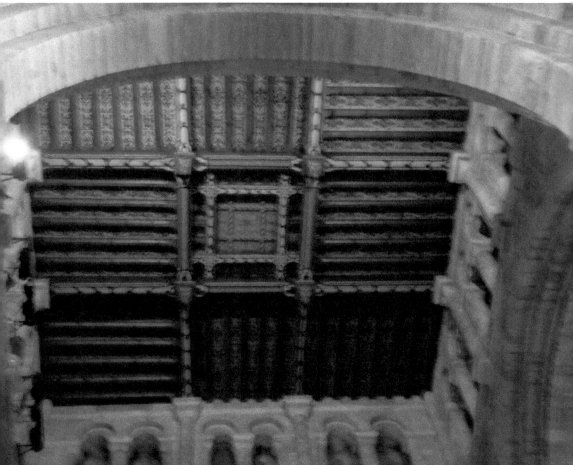

16. Mottisfont Abbey

Mottisfont Abbey was founded in 1202 as an Augustinian priory dedicated to the Priory Church of the Holy Trinity. Standing on the banks of the River Test amid beautiful surroundings, it provided ministry and accommodation for pilgrims bound for Winchester, which continued over the centuries until the Dissolution of the Monasteries during the reign of Henry VIII. In the aftermath the abbey was purchased and converted into a large country house. It retained the main nave of the abbey, but a new south front and side wings were built in 1740. Today the property is maintained by the National Trust where a stunning walled garden sited away from the main house displays ancient roses in the summer months, while in the main garden there are carpets of bulbs in the spring as well as a winter garden with 60,000 bulbs according to the guide. Although most of the original medieval fabric has been lost, the thirteenth-century *cellarium* remains in the basement area. Exhibitions are also held in the main gallery of the house where the famous Rex Whistler decorations of 1938–39 in the salon are painted in the *trompe-l'oel* manner, giving a fascinating three-dimensional effect to the images. Outside in the old stable yard there is a new visitor's centre, completed in 2016, which is heated by a biomass boiler using woodchips from the estate.

The River Test flowing through the beautiful landscaped gardens of Mottisfont Abbey.

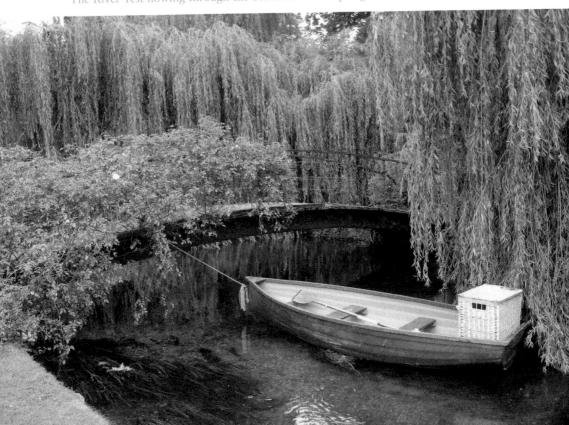

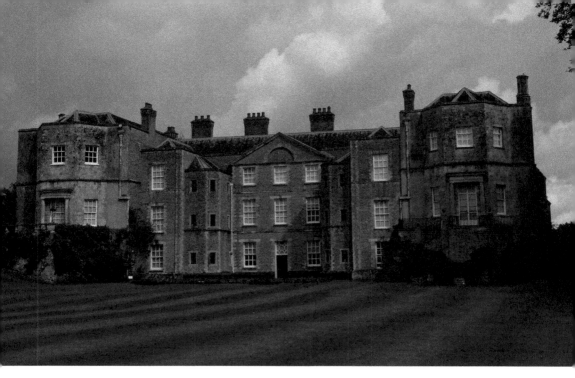

Above: The south front with later additions to the original abbey.

Below: North front of the original abbey.

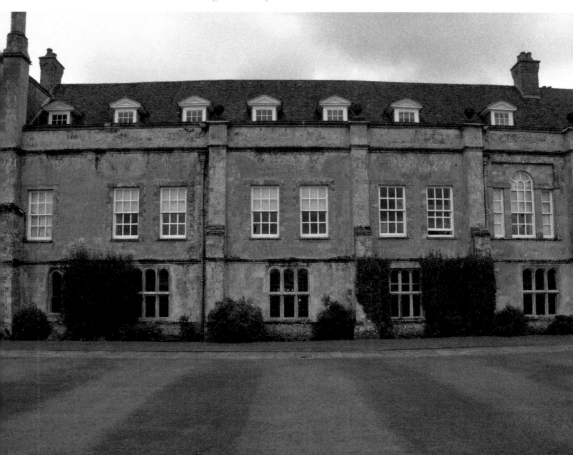

17. River Itchen

The source of the River Itchen is at the village of Cheriton. It has a length of 28 miles and meets at its confluence with the River Test in Southampton Water. The main stream flows over a chalk bed, which acts as an aquifer, filtration and storage for water supply to the surrounding areas. After leaving its source the river flows north towards New and Old Alresford and is joined by the River Alre, all part of a riverside town founded in the thirteenth century by Bishop Godfrey de Lucy as a commercial enterprise to create a navigable link with Winchester. This was achieved by the creation of the Arlesford Great Pond and Reservoir by building a dam over the River Alre and the formation of the Great Weir across which today the road links Old and New Arlesford. The whole purpose of the Great Pond was to retain sufficient water to maintain water levels in the River Itchen sufficient for trade and water transportation purposes. The late John Duthy observed: 'By Deepening the channel of the Alre and Itchen, by regulating its supply from the Great Reservoir, De Lucy rendered the main stream navigable from Alresford to Winchester.' Alongside these great courses the watercress beds for which Alresford is famous are seen. The River Itchen flows west to Abbotts Worthy and then to Winchester where the main channel passes through Winchester City Mill. The river heads south through water meadows, past the Hospital of St Cross and afterwards through Twyford and on to Eastliegh, Mansbridge and Southampton itself. In Southampton the River Itchen passes beneath three bridges, namely the Cobden Bridge, Northam Bridge and the majestic Itchen Bridge.

18. Winchester

The city of Winchester is Roman in origin, dating from 50 BC and originally called Venta Belgarum. It was 12 miles north of the Roman fortified settlement of Clausentum in Southampton, at the mouth of the Rive Itchen, on which Winchester is also located. This, the first of the 'new towns', was of truly urban proportions

in area (around 58 hectares), standing on the banks of the River Itchen, which had been diverted by the Roman engineers to accommodate the overall layout within enclosing walls. In addition, and most interestingly, the town was orientated on a south-westerly axis in line with the prevailing south-west winds. Archaeological examinations have since established that, in line with Roman tradition, the dead were buried outside the town to the north to protect the water supply, which nevertheless was already compromised by the use of lead piping, indicated by high lead content in the bones of bodies excavated.

19. St Catherine's Hill

This isolated Stone Age fort, last occupied between 300 and 100 BC, was situated strategically alongside a narrow section of the River Itchen Valley around 2 miles south-east of Winchester and was finally abandoned in Roman times. The entrance was on the north-east side, leading to the summit of 67 metres and the site of the original St Catherine's Chapel, now surrounded by a large copse of beech trees all within a total area of 9.3 hectares and visible for miles around. The hill overall is owned by Winchester College and managed by the Hampshire and Isle of Wight Wild Life Trust. There is a mizmaze cut into the chalk dating from 1647–1710, a place of outside prayer and contemplation in relation to the chapel. The whole hill is within a site of Special Scientific Interest and is separated from Twyford Down by the M3, located on the edge of the South Downs National Park. St Catherine's Hill overlooks the Itchen Water Meadows to the west and the grounds of the Hospital of St Cross and can be accessed from Garnier Road and Bull Drove towards Junction 10 of the M3. Like its neighbour St Giles Hill at the end of the High Street in Winchester, St Catherine's Hill was the site of a market approved by royal decree and is where the scholars of Winchester College once played football.

20. Winchester Cathedral

After the Norman Conquest of 1066 a new cathedral was begun in 1079 by Bishop Walkelin with stone quarried in the Isle of Wight and brought to Winchester as ship's ballast. This was essentially a robust structure signifying the conquest and the obliteration of the Saxon culture beforehand. Later in the fourteenth century Bishop William of Wykeham transformed and extended the nave in the Perpendicular style, signifying a cultural change in the country. His beautiful chantry chapel in the west end of the nave is a reminder of his achievements. Nearby outside the Cathedral Precinct, where Bishop William founded the world famous Winchester College – the

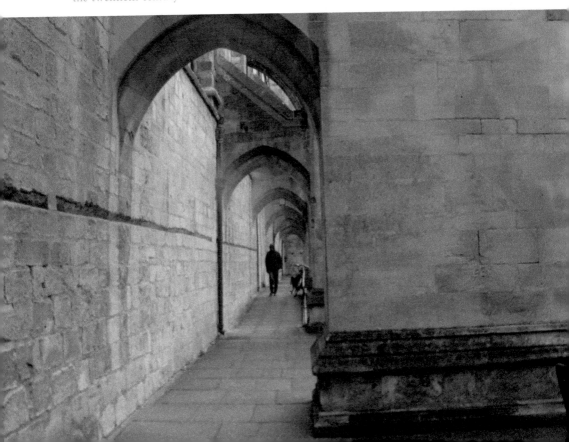

Right: Victorian engraving from
c. 1836 showing the interior of the
Norman north transept. (Courtesy of
WIT Press Southampton)

Below: Colonnade of massive stone
and flying buttresses on the south side
of the cathedral nave, forming part of
the twentieth-century restoration.

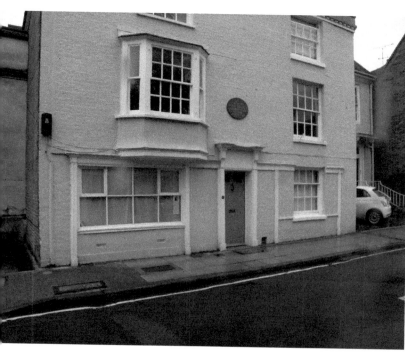

Left: Jane
Austen's house
in College
Street.

Below: College
Street.

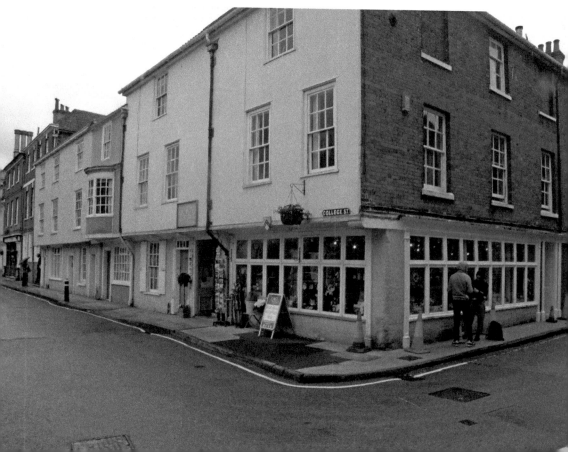

first scholars were admitted in 1394. There is the apocryphal story to explain why his chantry chapel was unscathed by Cromwell's troops in the Civil War: the officer in charge was a Wykehamist. In the crypt of the cathedral flooding often occurs, signifying difficult ground conditions. Things came to a head in the early twentieth century when the entire cathedral's foundations were underpinned by a diver, William Walker, to prevent a catastrophic collapse. In the north aisle of the nave is the grave of Jane Austen, who died in her house in College Street nearby in 1817.

21. Hospital of St Cross

The Hospital of St Cross was founded at Winchester in 1136 by Henry de Blois, Bishop of Winchester, who was the grandson of William I. It began – and remains – a charitable institution, 'to support thirteen poor and impotent men'. This institution is arranged around two quadrangles: a smaller one entered beneath the fifteenth-century Beaufort Tower; the other larger one dominated by the view of the late

Eighteenth-century engraving. (Courtesy of WIT Press Southampton)

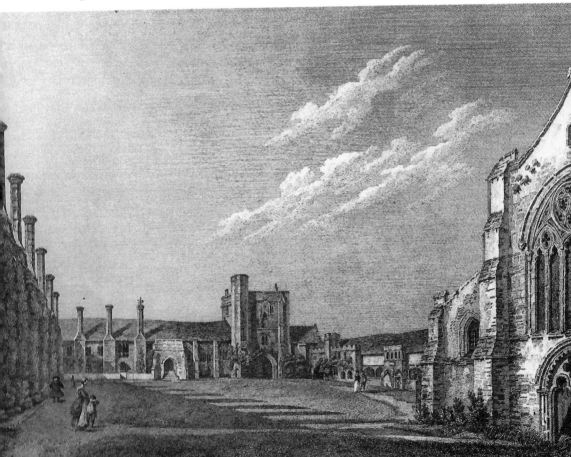

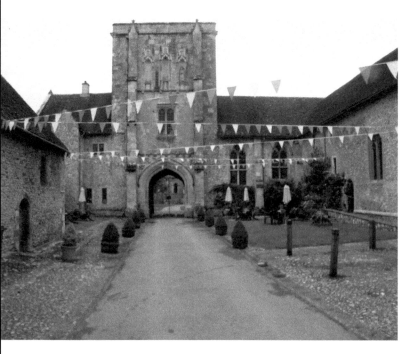

Left: Entrance via Beaufort Tower.

Below: Brothers' quarters (west side) and entrance to the Hundred Men's Hall (north side).

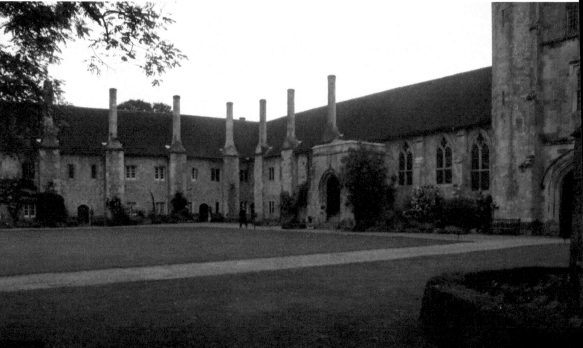

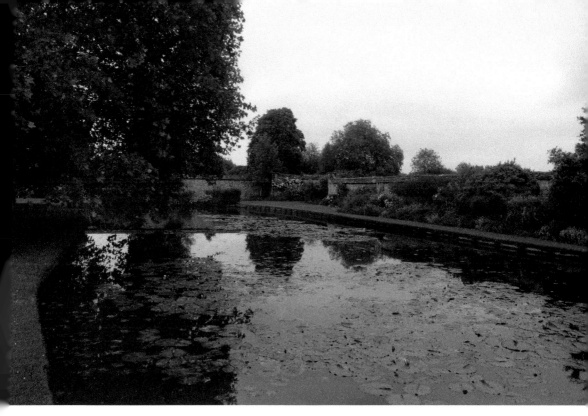

Above and below: The master's garden.

Norman Church of St Cross together with the world famous brothers' quarters, master's lodge, fourteenth-century brethrens' hall, outer gate and porter's lodge, where bread and beer was dispensed to weary travellers on the Pilgrims Way to Canterbury. After the porter's lodge there is a colonnaded approach to the north porch of the church, outside which is the master's garden where a unique collection of trees from North America completes this amazing and beautiful place. Henry Beaufort, Bishop of Winchester in the fifteenth century, was responsible for extending the almshouses to include the Order of Noble Poverty for servants of the state 'for those who once had everything handsome about them, but had suffered losses', although today all men of sixty years of age 'who are of good character and able bodied' are eligible to live in these brothers' quarters, which comprise one bedroom, living room and all facilities. Today this venerable institution remains as a testament to the power and riches of the medieval Church.

22. Cathedral Close

Winchester Cathedral's iconic Close is entered by the fifteenth-century Prior's Gate in St Swithun Street through stone walls some 2 metres thick, with castellations and a coat of arms at roof level via an elegant pointed Gothic archway. Adjacent stands the King's Gate in the city wall, over which the beautiful Church of St Swithun is situated. Immediately inside the Close there is Cheney Court, which is also of the fifteenth century and was once the bishop's courthouse, a distinctive timber-framed building over the flint and stone walls of the ground floor, with its projecting jetty feature. Within the Close are the remains of the previous abbey cloisters, which were destroyed in the sixteenth century during the Dissolution of the Monasteries.

Prior's Gate, St Swithun Street, seen from the undercroft of the King's Gate.

Above: Vaulted arch and a shop with the church above, St Swithun-upon-Kingsgate.

Below: The 'Slype' adjacent to the remains of the old chapter house.

In a passage called the Slype, the remains of the old chapter house have survived, described by Pevsner 'as one of the mightiest pieces of Norman architecture in the land'. The land on which this old chapter house once stood is now the Bishop Stephen Gardiner Memorial Garden. Within the Close the original prior's lodgings and prior's hall now form part of the deanery. Some of the original ecclesiastical buildings have been adapted for residential use; for instance, No. 10 the Close, home of the cathedral's musical director, features a beautiful thirteenth-century vaulted room. No. 1 the Close is described on John Speed's map of 1611 as 'Paradise'. On the Ordnance Survey map of 1873 the Outer Close (to the north of the cathedral), the sites of both the Old Minster and New Minster can be seen, as well as the site of the Norman Palace in the High Street, adjacent to St Lawrence's Church and the cathedral outer precinct.

23. High Street

The High Street in Winchester has Saxon and Norman origins and is an important spine road. It links from the Westgate eastwards to where it connects with the Broadway (marked by the dramatic statue of King Alfred), leading to the City Bridge, which crosses the River Itchen – all seen against the backdrop of St Giles Hill.

The 'Pentice' (sometimes called 'Piazza') with its beautiful colonnade of cast-iron columns and covered walkway.

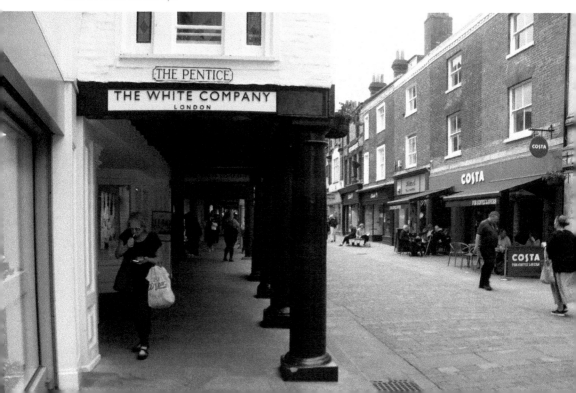

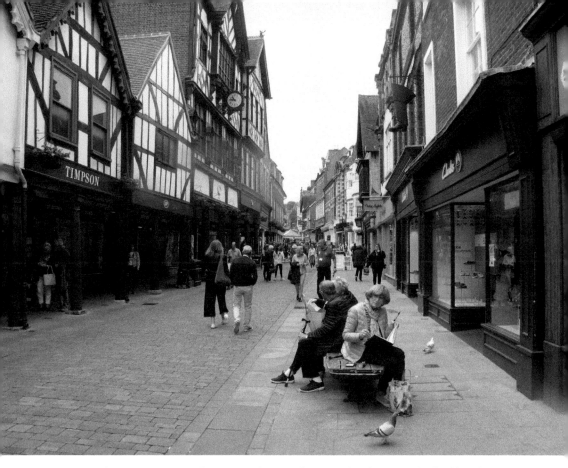

Immaculate paving in Winchester's High Street between developments both old and new.

Standing midway along this road is the tall and elegant fifteenth-century Buttercross, marking the site of a medieval market where, as the name suggests, butter was sold. Close by is the pentice (once called piazza) where the pathway has been roofed over by a beautiful colonnade of cast-iron columns, supporting residential accommodation above, with the remaining pentice extending eastwards for a distance towards the junction with Market Street. This section of the High Street has been beautifully paved today as part of a pedestrian precinct – between Jewry Street to the west and Colebrook Street and the Guildhall to the east. Historically the Paving Commissioners, who met for the first time in 1771, decreed that the High Street be paved with a good surface of flint, together with the pathways and entrances to shops; and later in 1785 street lighting was introduced. Beforehand, during the reign of Charles II in 1683, the inhabitants were obliged to hang lamps in front of their shops or houses and sweep and maintain the road outside. Perhaps one of the most intriguing buildings in the High Street is the present premises of Lloyds Bank (at Nos 48–49), formerly the Old Guildhall, which was used since 1349 as the Hall of Court where the Mayor of Winchester and two bailiffs heard cases in the Court of Record. After many vicissitudes and changes over the years, when the façade was again remodelled in 1915 by Thomas Stopher, it became a bank. A significant feature of the overall classical design is its lead covered cupola, from where each day the curfew bell is still rung, making this building of significant historical importance. The present Guildhall in the Broadway became the formal meeting place of the Corporation when it opened in 1873.

24 and 25. Winchester Mill and Abbey Gardens

The Winchester City Mill and Abbey Gardens are grouped around the River Itchen and eastern city wall, and marked by a plaque. Winchester City Mill was first recorded in the Domesday Book for the milling of corn. It was originally called the Eastgate Mill until 1554 when Queen Mary Tudor gave it to the city, together with Abbey Gardens, following her marriage to Philip I of Spain in the cathedral. The mill was last rebuilt in 1744 by James Cook, a tanner, and later in 1820 sold by the Corporation to John Benham, remaining in use until the 1900s. In order to avoid demolition it was sold to the National Trust in 1931 and is now, after a restoration programme in 2004, leased to the YHA as an activity centre as well as supporting the activities of the Hampshire and Isle of Wight Wild Life Trust and its 'otter watch' programme. Abbey Gardens and the mill nearby once shared the site of St Mary's Abbey, one of the largest religious houses in England, where its 'nunnaminster' was

Winchester Mill interior (now managed by the National Trust).

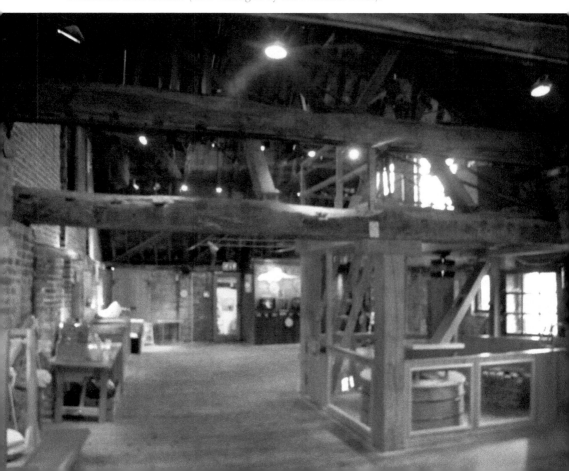

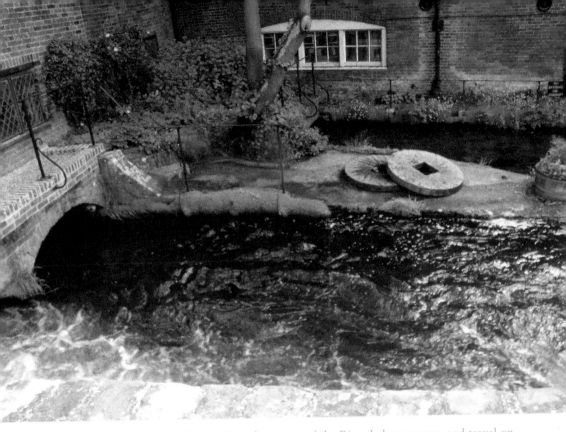

Above: An exciting mill race where the waters of the River Itchen emerge, and travel on to meet the sea in Southampton Water.

Below: Old Town Bridge over River Itchen.

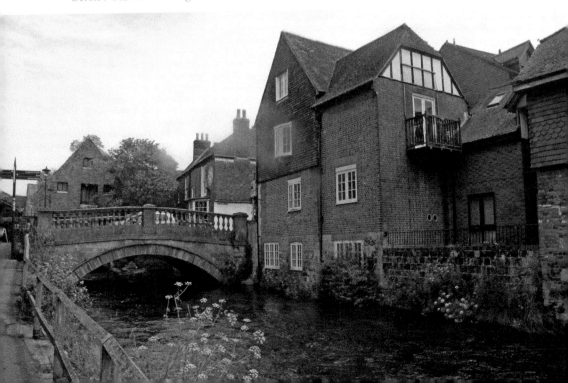

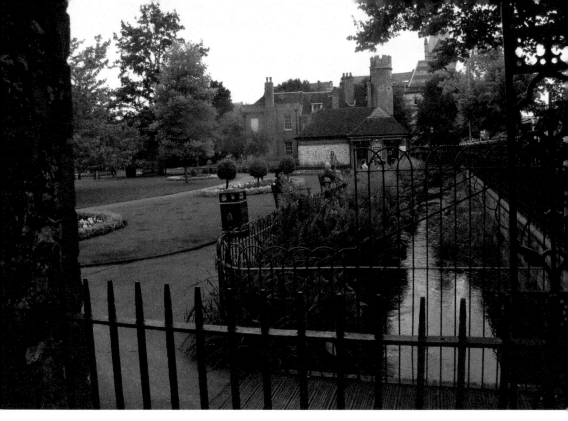

Abbey Gardens mill stream.

founded in 903. At the Dissolution of the Monasteries the monastic buildings were surrendered to the Crown in 1539 and all the buildings demolished. In 1544 the site was divided into two, where later the present Guildhall was built in 1873 together with the mayor's residence in the eastern part. The remainder became formal public gardens. At the rear of the Guildhall remains of the abbey can be seen. The abbey mill stream passes through this site, sections of which are visible, all part of the interlacing pattern of streams from the River Itchen, while other parts run roaring underground, all part of the mysticism and beauty of this place.

26. Wolvesey Palace and Riverside Walk

Further alongside the River Itchen, beyond the City Mill, is a further mill that is linked by a waterside pathway conjoined with the beautiful and majestic rubble stone walls surrounding the historic site of Wolvesey Palace, built jointly by bishops William Giffard and Henry de Blois in the twelfth century. The palace was essentially a rectangular building with a massive west hall built by William Giffard before his

death in 1171, and an east hall constructed by Henry de Blois. All were arranged around a grand central courtyard, with Wymond's Tower on the south-east wall and Woodman's Gate on the north side – its main entrance. Originally the palace building was surrounded by a moat on all four sides according to Martin Biddle's reconstruction and contained a chapel and a keep tower, all separate from the enclosing walls outside. Today there are but traces of this once important edifice: remains of the east hall by Henry de Blois in 1135–38, constructed in part by Caen stone from and quarries from Quarr in the Isle of Wight, together with material from the remains of William the Conqueror's redundant palace next to the High Street. Previously, when this site was managed by English Heritage, public access was encouraged but now steel gates protect the land as it is now a Pilgrims School sports facility. Bishop Henry's fame rests with his wealth and entrepreneurial capability in creating episcopal developments over central southern England, some with humanitarian benefits like the Hospital of St Cross and leper colony in 1148 at St Mary Magdalene's Chapel at St Giles Hill.

Mill Stream in Abbey Gardens.

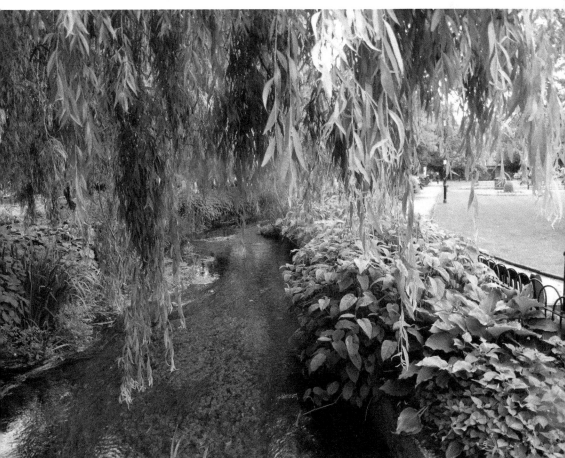

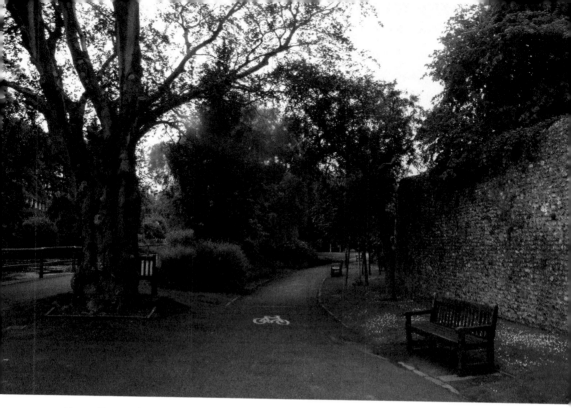

Above: External walls to Wolvesey Palace.

Below: Gardens in Riverside Walk.

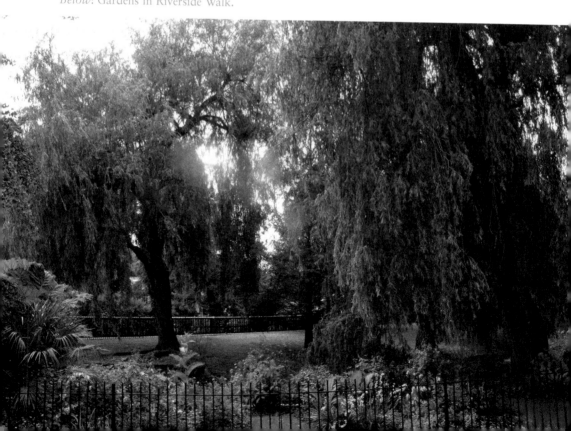

27. Hursley

Hursley is an iconic Hampshire village, sited on the B3335 Romsey Road leading on to Winchester. It has a sixteenth-century inn (the Dolphin), shops, houses, post office (now closed), and the Victorian All Saints' Church where John Keble, the high churchman, was once vicar from 1836 to 1866. Inside Hursley Park nearby lies the research and development headquarters of IBM, famed for computer technology, sited discretely away in the lush landscaped setting. It was initially located in Hursley House, a Grade II* listed building, but subsequently extended with contemporary laboratory buildings and a gymnasium, and now employs 1,500 people. Around half a mile north are the remains of Merdon Castle, which was founded in 1138 by Bishop Henry de Blois as an episcopal fortified residence on the site of a Bronze Age fortification and earthworks. It is now enclosed by a circular, and seemingly continuous, boundary wall hard against a very narrow road beneath the dense and dark foliage of a canopy of trees above, creating an eerie sense of foreboding. The fame of Hursley village rests with its church and one-time vicar John Keble (1792–1866), who in 1827 wrote and published the *Christian Year,* a book of poems

The Victorian All Saints' Church.

Hursley village centre and old post office.

for Sunday worship and feast days of the Christian year. This publication was highly successful and earned him the post of Chair of Poetry at the University of Oxford from 1831 to 1841, and after his death Keble College in Oxford was named in his honour in 1869. John Keble was also responsible for the building of the present parish church in 1846 to 1848, to the design of J. P. Harrison for the sum of £6,000, paid for from the royalties of his books. Today All Saints' Church sits serenely in its large churchyard alongside the village's main road together with the beautiful lychgate at the entrance to the consecrated grounds.

Southampton and Southampton Water

The old medieval town walls of Southampton are laid out in an elongated rectangle, north to south, and sit immediately adjacent to the shores of Southampton Water. The surviving walls of this fantastic structure face westerly towards the sea, defended by the Westgate and northerly to the town entrance by the famous Bargate, also called the 'Entrance to England'; in total, these walls stretch for a distance of 1.25 miles. Southampton Water is a tidal estuary north of the Solent and the Isle of Wight. Along the salt marshes of its western shore waterside lie the New Forest and the villages of Hythe and Marchwood. On the eastern banks are the Southampton suburbs of Weston and its iconic sweeping shoreline alongside Southampton Water,

Eling Mill and Causeway.

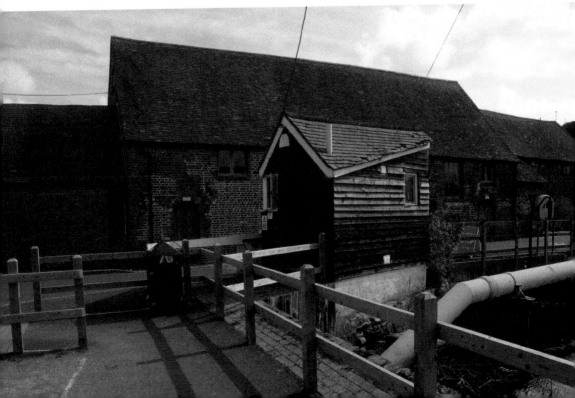

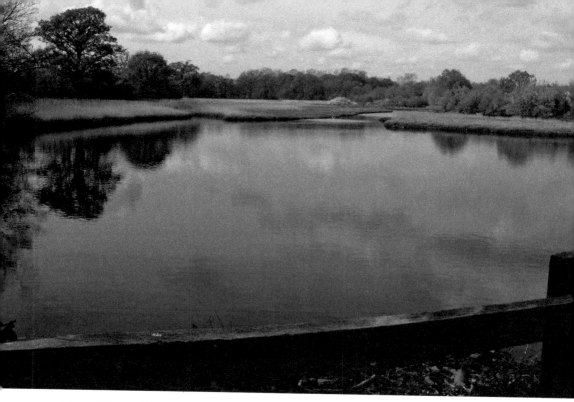

Above: Eling Mill and Reservoir.

Below: Yachts in Eling Wharf adjacent to Eling Marches and the Redbridge Channel where the River Test joins Southampton Water.

leading on to Netley and its abbey, castle and the Royal Victoria Country Park. Southampton is a major shipping port, assisted by its double tides, noted as early as the eight century when the Venerable Bede wrote, 'in this narrow sea the two tides of the sea daily meet and oppose one another beyond the north of the River Homlea [Hamble].' These dual tides, each of one hour ebb and flow, gives a daily duration of four hours of high tide, especially beneficial to the safe movement of large ships carrying containers and cruise liners. In the suburb of Bitterne, in the grounds of Bitterne Manor, are the remains of the Roman town of Clausentum, the fortified encampment at the mouth of the River Itchen, dating from the invasion of the year AD 43. It is here that John Arlott wrote his poem 'By Night'; the opening line 'The South-west wind goes down before the night' refers to Southampton's famous prevailing wind.

Of special interest on the western side of Southampton Water is the tiny village of Eling, together with its watermill and the immediately adjacent Saxon St Mary's Church and rectory, all three of which are Grade II*listed buildings. Eling lies at the very top of Southampton Water close to the spot where the mouth of River Test emerges past the reed beds at Redbridge Causeway and joins the tidal estuary. Eling Tide Mill is very ancient and is mentioned in the Domesday Book together with its church, and is said to be the only remaining tide mill in the world still producing flour. Being a tide mill, it is built on the causeway across the tidal estuary, forming both a bridge and a dam when the tide fills the space behind held against sluice gates, which can then be opened to drive the watermill for around five hours each tide. Interestingly, in 1382 William of Wykeham, Bishop of Winchester, granted this watermill to Winchester College as part of its endowment, and it remained in the same ownership until 1975. It is now in the property of the New Forest district and forms part of the Totton and Eling Heritage Centre. Today tolls are still charged to drive over the causeway at a charge of £1 per car. Without doubt this is a surreally beautiful and peaceful place to visit and take in the absolute quietness here.

28. Eling Mill and Marchwood

Marchwood village lays close to Eling on Southampton Water, and is also situated near to Hythe, which has its own pier and landing stage with ferry services to Southampton terminal and onward links to the Isle of Wight. Access to Marchwood is via the A326, with the Marchwood bypass leaving local roads free from through traffic in this waterside town, creating a quiet and sequestered place to visit. Two comfortable nights were spent in the Roebuck Inn in the village centre, providing a base to explore these far reaches of the New Forest and towns along Southampton Water. Close to the village we found the impressive parish church, St John the Apostle, with its high tower and steeple set in beautiful open green space – all incredibly quiet, almost as if time had stood still. Gone is the power station that once dominated the skyline, replaced by the far away images of the cranes in the dockland area. Throughout, however, Marchwood retains is maritime image and character.

Marchwood Church of St John the Apostle.

This town is mentioned in the Domesday Book where it was called Merceode. The manor of Marchwood, once called Marchwood Romsey, was held by John de Romsey in 1316. Marchwood was originally part of the parish of Eling, but in 1843 it became a separate ecclesiastical parish when the present new church was designed by J. M. Derick in the Gothic Revival style fashionable at the time.

29. Weston Shore

Now on the eastern side of Southampton Water, the village of Weston has the small and picturesque Church of the Holy Trinity in Weston Lane (1805), designed by the architect A. Bedborough according to Pevsner and Lloyd. The village is also home to Weston Shore, which runs alongside the full length of Weston Parade, and the beautiful waterside, which has been subject to the vagaries of the constantly changing weather of the seafront. This is a favourite place for Southampton's residents to visit and enjoy the scene with distant views across to the New Forest and the ever-changing spectacle of ships both large and small passing by.

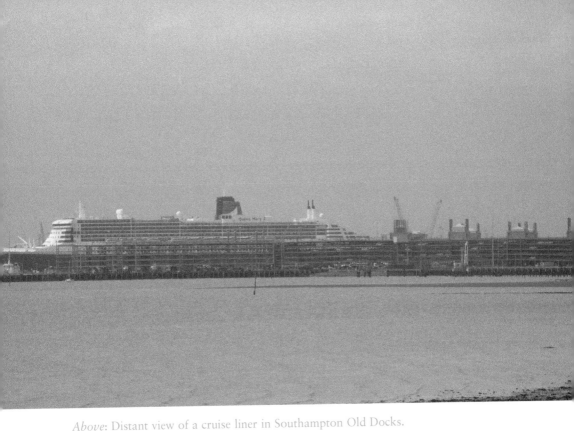

Above: Distant view of a cruise liner in Southampton Old Docks.

Below: General view of the windswept beach of Weston Shore.

30 and 31. Victoria Park and Hospital

The Royal Victoria Military Hospital, built in 1856 to 1863, was the main military hospital in Britain, containing 1,000 beds for casualties of war for both the First and Second World Wars. It closed in 1958 and was demolished in 1966, leaving only the chapel and tower (now a museum). There is a military cemetery to the rear of the hospital site where among those buried are 639 Commonwealth personnel who died in the First World War and thirty-five in the Second World War. It is now maintained and registered by the Commonwealth War Graves Commission. Surrounded by the majestic Royal Victoria Country Park, this is now a place of relaxation and pleasure and a fitting reminder and tribute to the brave hospital patients who were once here. Today the country park is an immensely popular tourist attraction with a visitors centre, which does not detract from the solemnity of the history of its grounds.

Victoria Hospital.

Victoria Hospital and Park.

32. Netley Abbey

Netley Abbey was founded in 1240/1 as a Cistercian foundation and the first abbot was appointed in 1245. Henry III made grants for its foundation and became its patron. At the base of the north-east crossing of the church, begun in 1246, there is an inscription confirming this. In addition, the king's mason at Westminster Abbey came here to work on its construction in Caen masonry. At the Dissolution of the

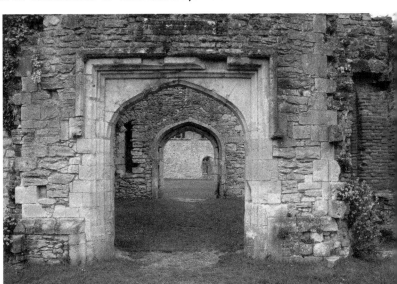

Netley Abbey
entrance.

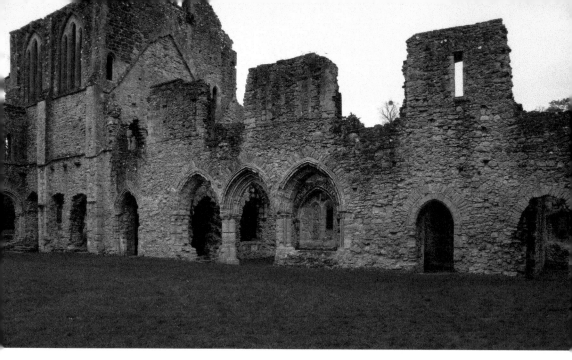

Netley Abbey, now a stabilised ruin and historic monument, alongside Southampton Water.

Monasteries the abbey fell into dereliction and its stone was used elsewhere. Today it is a stabilised and majestic ruin, which after the restoration of the monarchy was converted to an elaborate brick-built residence according to a display on the site. However there is absolutely no trace of this building today, only the original weathered stone of this once monumental and historic abbey. Ever since I first visited this site it was clear to me that the location had been carefully chosen by the original monks for its serene quietness close to the banks of Southampton Water.

33. Southampton Medieval Town Walls

The town walls of Southampton are essentially Norman in origin and today form an important part in the growth of the history of the town, in addition to being a major tourist attraction. Over the intervening years modifications to these sea defences against invasion have changed the overall appearance. For instance, after the infamous French raid of 1338 when the town was almost completely destroyed, Edward III ordered immediate upgrading of the town walls, which over a period of time included twenty-nine towers and eight fortified gates, including the West Gate, giving access to the then Town Quay. Throughout this time the waters of the sea lapped against the west and south walls, with a shingle beach over an area now occupied by modern developments along the western esplanade. In addition to the east side were additional defences by way of a 'fosse' or deep ditch, where there was

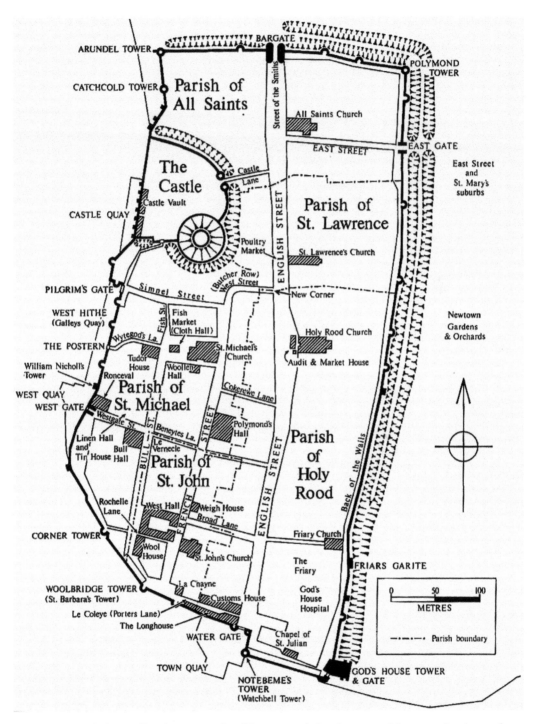

Map of the medieval town walls. (Courtesy of Southampton Museums Service and Dr J. Hodgson)

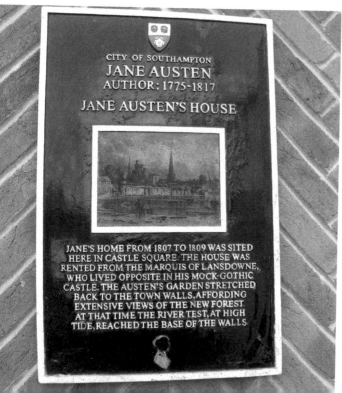

JANE'S HOME FROM 1807 TO 1809 WAS SITED HERE IN CASTLE SQUARE. THE HOUSE WAS RENTED FROM THE MARQUIS OF LANSDOWNE, WHO LIVED OPPOSITE IN HIS MOCK-GOTHIC CASTLE. THE AUSTEN'S GARDEN STRETCHED BACK TO THE TOWN WALLS, AFFORDING EXTENSIVE VIEWS OF THE NEW FOREST. AT THAT TIME THE RIVER TEST, AT HIGH TIDE, REACHED THE BASE OF THE WALLS.

CITY OF SOUTHAMPTON
JANE AUSTEN
AUTHOR: 1775-1817

JANE AUSTEN'S HOUSE

Above: Looking down to the contemporary floor where once seawater lapped against the old town walls.

Left: Wall plaque recording site where Jane Austen lived from 1805–09, in a house within the medieval walled town.

no protection from the sea. Without doubt the single most significant building of the overall defences of the town wall is the Bargate, situated between Above Bar to the north and the High Street to the south, through which all trade passed and tolls were collected. Above the Bargate is the old Town Hall, or Sessions Hall as it was once called, where the curfew bell tolled for security and when the main gates closed at night. In 1380 the mason Henry Yevele, after carrying out improvements to the castle, was responsible for building the spectacular five arches to the arcades along the western town walls, blocking up openings created by merchants in order to make the walls more tougher to attack. Further along, outside the town walls and to the south, is the iconic *Mayflower* memorial to the Pilgrim Fathers, who embarked on one of the two original ships that left Southampton via the West Gate for Plymouth and began the epic voyage on the *Mayflower* to America.

34. Southampton Common

Southampton Common is one of the best-known open spaces within the environs of the city, comparable with the city parks and vast waterfront. It sits neatly alongside the adjoining suburbs of Bassett to the north and Portswood and Swaythling to the east, where it meets the busy Hill Lane for the full length of its western boundary.

Southampton Old Cemetery's entrance gates opposite a restored Victorian chapel, all on a Site of Special Scientific Interest.

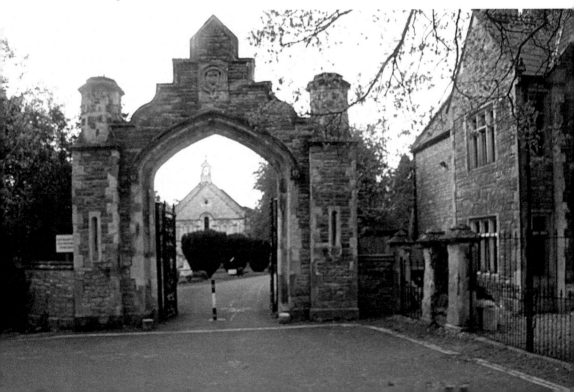

The majestic avenue forms its principal tree-lined approach from Winchester, running north to south towards the city centre, once described as 'This is a very fine approach, very gradual and artful, in progression from country to town' (J. B. Priestly, *English Journey*). The common comprises an area of some 365 acres, combining woodland, open parkland, rough pasture and nature trails in the Hawthorns Wildlife Centre, sited on land previously the home of Chipperfield's Southampton Zoological Garden. A principal feature of the common is the Cowherds Inn, dating from 1762 when it housed the cowherd and his family for a rent of £6 per year – as the name suggests, he was responsible for looking after cattle grazing on the common. The cowherd was granted a licence to brew beer in order to supplement his income to offset his rent – an arrangement that was the forerunner of the later licenced premises here. Nearby and to the south is the Southampton Old Cemetery, originally part of the common. It was designed by the Scottish botanist John Claudius Loudon (1783–1843) as a botanical garden, laid out for relaxation and pleasure rather than a place of mourning, and became his final project when he died in 1843. Within this cemetery three chapels were built to cater for the diverse nationalities and religions in Victorian Southampton, including the Church of England, Nonconformists and Jews, the largest of which was the Church of England Mortuary Chapel, a Grade II listed building that was purchased from the council for £1 by the Southampton and Solent Building Preservation Trust and subsequently restored from a state of dereliction and later removed from the Buildings At Risk register. Today Southampton Old Cemetery has been designated an area of Special Scientific Interest and is truly part of the overall glory of Southampton Common.

Chapel in Southampton Old Cemetery.

Entrance to
Southampton
Old Cemetery
Arboretum.

35. High Street

The High Street, formerly English Street, is the principal street situated with the old town walls and links the Bargate to the north and Southampton Water to the south. It was the centre of business in the town and home to all the major banks in Southampton, including the Bank of England. Today there is a scene of change after the new developments following the Second World War when the entire street was almost completely destroyed. Two major Coaching Inns miraculously survived, however, including the Star Inn and the Dolphin Hotel. The Star Hotel (formerly Inn) is a typical coaching inn with a central porch to let coaches through. It has a plaque that reads, 'Coach to London, Sundays excepted, Alresford and Alton, performs in 10 hours'. This inn is mentioned in the deeds of 1600 as 'a tenement of the Priory of St Denys'. In 1831 Princess Victoria stayed here, and her coat of arms is high on the pediment of the front elevation to the High Street. Later, as Queen Victoria, she came to Southampton with her entourage en route to Osborne House, her home on the Isle of Wight, stopping at a chemist in Shirley High Street to pick up supplies for the visit. The Dolphin Hotel was first mentioned in documentation of 1267 and later in 1647 as belonging to the wardens of the Church of the Holy Rood (immediately adjacent), now a stabilised ruin after war damage, retaining the tower and serving as a memorial garden for sailors lost at sea. The Dolphin Hotel, with its twin two-storey bay windows alongside the central archway, is both symbolic of Georgian architecture and typical of the day. A plaque records that Jane Austen celebrated her eighteenth birthday here in company with her brother Frank while staying with the family of the Mayor of Southampton.

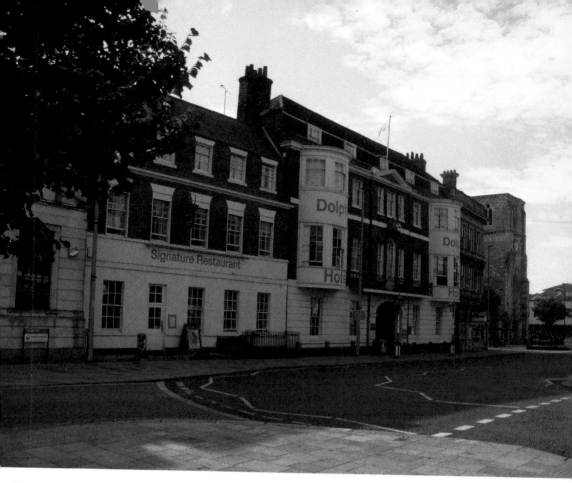

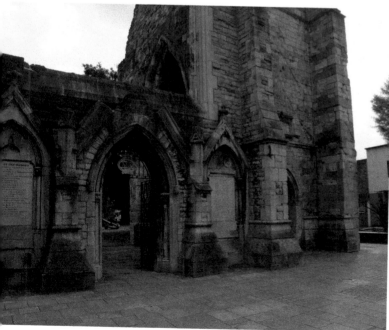

Above: Dolphin
Hotel with
Jane Austen
connections.

Left: Holy Rood
Church, now a
stabilised ruin.

36. Clausentum

Clausentum is the Roman name for a small fortified town on a promontory at the mouth of the River Itchen, which was sited on an open U-shaped configuration, allowing all-round visibility for defence. Originally the site was protected with water of the River Itchen on three sides and a flint and stone wall, together with twin defensive open ditches with wooden stockades on the landward side, which ensured a safe harbour and protection for the approach to the important town of Winchester, 'Venta Belgarum', 15 miles to the north on the same river, as well as security for access to the Isle of Wight. The manning of this small fortress lasted from the Roman invasion in the year 43 until the final withdrawal in 410, supported by the evidence of Roman coins found here in later excavations of the site. Additionally, this town was part of the original famous Icknield Street, which together with the Fosse Way, Ermine Street and Watling Street, formed part of the road system of the Antonine Itinerary (compiled in 320), giving access to the towns of the Roman occupation of

Victorian map of Southampton showing Clausentum.

Britain. Today the main visible signs of this town of the first and fourth centuries can be seen in the garden of Bitterne Manor (now converted to apartments by the architect Herbert Collins), alongside which are the foundations of the Roman bathhouse as well as part of the defensive wall and 'fosse', or stockade and ditch.

37. Mansbridge

Mansbridge is a suburb in the Swaythling district of Southampton between two historic bridges spanning the River Itchen – one at Mansbridge to the north-east and the other at Woodmill to the south-west where the river joins its tidal estuary. Here the ancient salmon fisheries lay alongside the river, which was first used by

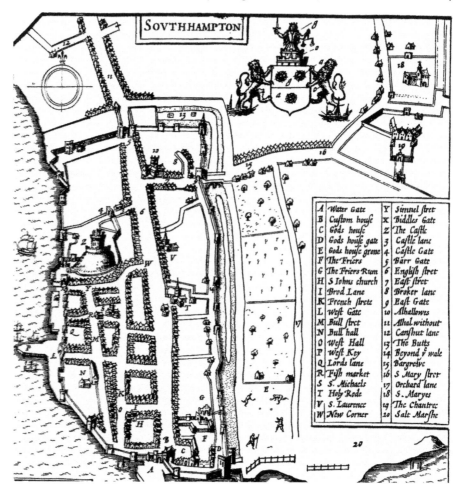

John Speed's map of Southampton, 1611.

monks in the ninth century to provide a plentiful supply of fresh food. At Woodmill there has been a mill here since Saxon times for the grinding of corn; it was recorded in the Domesday Book of 1086. This mill was on the property of Lord Swaythling, who lived nearby in South Stoneham House when the grounds were laid out by Lancelot Brown. The house was designed by Nicholas Hawksmoor in 1708 in the Queen Anne style (now a hall of residence for the University of Southampton). The mill-house is now an activity centre. It is a late Georgian red-brick building that was occupied in the eighteenth century by Walter Taylor, who specialised in block making for the Royal Navy. However, earlier in 1705 Henri de Portal was employed here in South Stoneham Mill to learn his trade of paper making while living in the Hugenot community in Winkle Street, Southampton. Later, to achieve fame and fortune, he produced paper for the Bank of England bank notes at his mill at Laverstoke in the Test Valley (now a Museum). The bridge at Mansbridge was once the southernmost crossing point of the River Itchen. It dates from 932 and is a Grade II listed building, and was originally called Mannysbrigge in the priory of St Swithun. It is mentioned in Leyland's itineraries of 1535 to 1543 and again on John Speed's map of 1611. Today it no longer carries road traffic over its single-arch stone bridge and sits quietly alongside the river, not far from the idyllic Swan Inn.

38. Bugle Street and St Michael's Square

Bugle Street was once known as Bull Street as this was where the bull horn was sounded in times of danger. Initially the houses were occupied by French merchants and many had basements, some vaulted, for the storage of wine. Historically Bugle Street led down to the waterfront and the Water Gate, as noted on John Speed's map of 1611. The properties overall are both domestic and commercial, and in medieval times they were favoured by wealthy merchants. Today some council housing exists in the ultra-modern Vyse Lane flats, which in part face the Bugle Street frontage, and are a welcome contrasting change to the timber-framed building nearby. Possibly the most important building in the street is Tudor House, at the junction of Bugle Street and Blue Anchor Lane. A late medieval townhouse, it remains essentially as it was when it was built in 1491–93 by Sir John Dawtrey, a wealthy merchant and MP for Southampton. In 1898–1902 this house was restored by William Spranger and converted to a museum, with its 'show façade' facing Bugle Street. Today it is called the Tudor House Museum. Immediately on the opposite side of the road is the iconic St Michael's Square and the Norman St Michael's Church, with its square tower and tapered octagonal steeple, while inside is the black Tournai marble font, one of only four in Hampshire. St Michael's Square was once the site of the Fish Market (again noted on John Speed's map of 1611), which was later resited alongside the West Gate where the Tudor Merchant's Hall now stands. Other interesting timber-framed buildings in Bugle Street include the Duke of Wellington public house, and on the

Above: Vyse Lane flats – a modern development built over the original medieval vaults.

Below: Tudor House Museum and Garden.

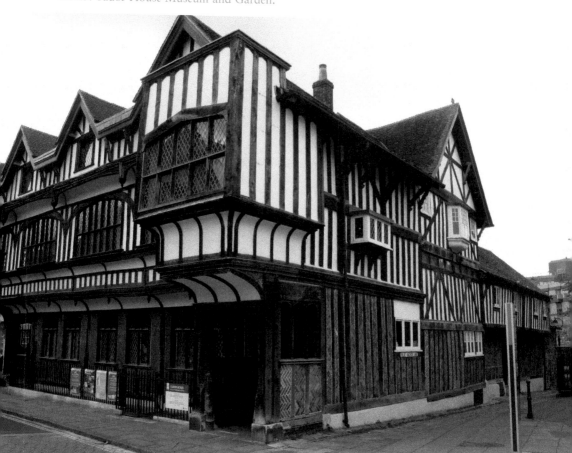

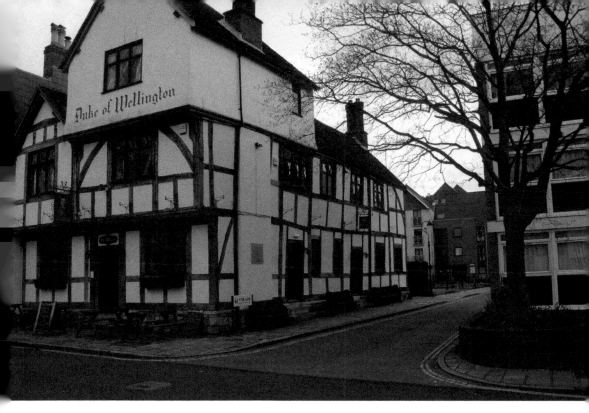

Above: The Wellington, Bugle Street.

Right: Normandy House, No. 45 Bugle Street.

opposite side of the road is No. 45 Normandy House, with its attractive Georgian bays on its upper two storeys, which has been extensively restored to its present condition. In West Street, a side road nearby, stands the historic West Gate, through which the Pilgrim Fathers set sail for America and where armies have passed through to the Battles of Crécy and Agincourt.

39. Southampton Castle

Originally Southampton Castle stood inside the walls of the Old Town, which was one of its major seaward defences, built originally between the Norman Conquest of 1066 and 1100 and substantially updated in 1378 in late response to the French raids of 1338 when Henry Yevele, the architect mason, was called upon to reconstruct the new keep tower to ensure the safety of this seat of government. Originally the castle, formerly a fortified residence, occupied a total of 3 acres of land within the parish of All Saints; however, today only parts of the original structure remain. In its completed state it comprised a circular keep on a raised mound called a motte, surrounded by a protective curtain or bailey wall – all part of a typical Norman motte-and-bailey castles. In addition, there were two protected entrance gates with the Water Gate on the sea side and the Castle East Gate. Most importantly the castle quay and castle vault were there to receive, control and protect all items of value entering the castle precinct. In the south-west corner the garderobe was sited, best described as a self-cleansing toilet arrangement (by the sea), for the entire castle. The castle was a prominent landmark and was a beacon for shipping when a brazier at its highest point would serve as a medieval lighthouse. John Leland, the sixteenth-century antiquarian, wrote in his itineraries that the castle was 'both large and fair, and very strong, both by worke and the site of it'. Today the mound on which the castle stood is home to impressive high-rise apartments called Castle House. It was designed by the architect Eric Lyons in the 1960s, who said he was not happy with his first design and 'prepared the current scheme free of charge to the council'.

View of Castle House, built on the site of the Castle Mound.

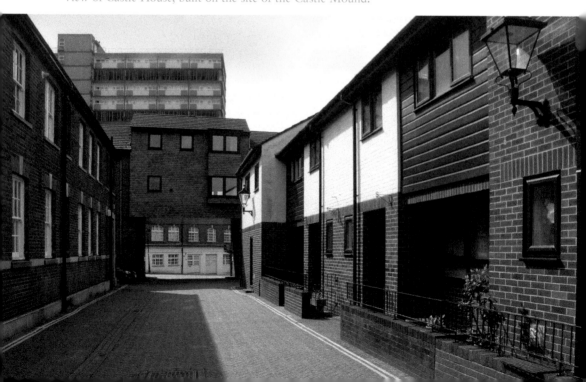

40. The Bargate

Equally impressive in the Old Town's defences is the Bargate, the 'Gateway to England', where all trade passed through its central archway. The Guildhall was once above (now a museum) but the Bargate now stands in splendid isolation. It is recorded Henry V addressed his troops here before departing to the Battle of Agincourt via Castle Street and the West Gate Pier. An engraving of 1820 depicts the south side of the Bargate with all its embellishments at the time, including twin lions each side of the central arch, the painted panels of Sir Bevis and his giant squire Ascupart, together with the crest of Southampton, with the Guildhall behind at first-floor level. The map of old Southampton, reproduced courtesy of Southampton Museums, is an encapsulation of the medieval Southampton still seen today. Pevsner described the Bargate as 'probably the finest and most certainly the most complex, town gateway in Britain'. Originally traffic passed through the main archway where the town broker sat taking tolls and noting them in the brokerage books. Town

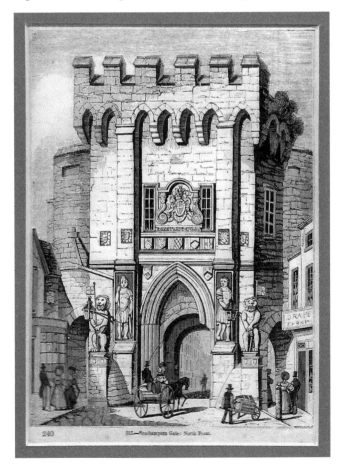

Victorian engraving of
Bargate north side.

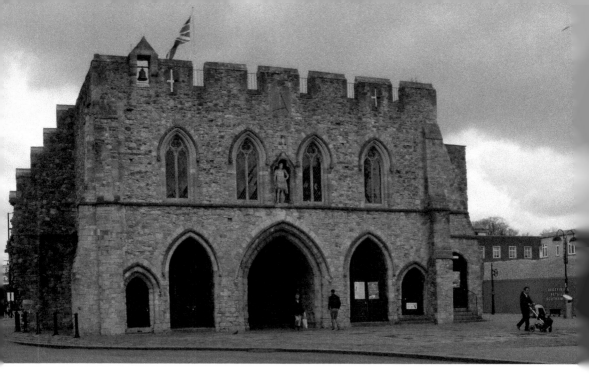

Bargate south side.

guilds met in the Guildhall where mayor-makings took place, and JPs held their courts here until 1934. In addition the court leet, held annually (called Law Day), held sway here from 1617–1856 to resolve minor disputes, which originally took place from 1550 in the open air on Southampton Common in an area called the Cutthorn Enclosure. Today what are called 'presentiments' can still be made annually at the Civic Centre Council Chamber by ordinary members of the public including schoolchildren. On the south side of the Guildhall, at roof level, there is the 'Watch Bell' or 'New Bell' with the inscription dated 1605: 'In God is my hope'. This is one of four such bells for ringing alarms in times of danger.

41. Herbert Collins' Uplands Estate

The Uplands estate in Highfield designed by the architect Herbert Collins is without doubt, in conception, a masterpiece of suburban design in the garden city traditions. On and along Highfield Lane in Southampton, interlinked with Southampton Common to the west, and Highfield Church and Portswood to the east, there is the beautiful arrangement of artisan houses and flats with mellow, pale red-brick walls punctuated by off-white painted Georgian-style windows and doors, with tiled roofs, in idyllic landscaped settings. Glebe Court alone stands in splendid isolation on Highfield Lane next door to the church and church hall (the one-time school). The layout is one of three terraces linked in a U-shaped formation around a central sunken green garden and accessed by gravel roads. There is an enormous holly hedge providing screening and privacy from the busy Highfield Lane outside. Almost opposite, in the pavement of

Above: Orchards Way.

Below: Orchards Way junction with Uplands Way.

House in Uplands Way.

Highfield Lane, are two brick piers and a wrought-iron gate where a medallion records the work of Herbert Collins: 'Architect and Planner for the Estate 1885-1975'. He was also referred to as 'Worker for Peace', referring to his involvement with the League of Nations and United Nations in Southampton. This may account for his egalitarian approach to his work here in the Uplands estate where the layout provides for ease of access for all and not a gated community. This is demonstrated by access through the gateway referred to above, leading to the pathway through the garden, a block of flats and downwards to Orchard Way, the centrepiece of the iconic Uplands estate. Houses here are set on a higher embankment with beautifully kept gardens stepping down to a gravel road, beyond which is an informal grassed area and stream at its junction with Uplands Way. It is interconnected here with Brookfield Road, which has a similar layout to Highfield Close with an idyllic garden setting with its houses framed by water. Pevsner and Lloyd wrote in their 1967 edition of *Hampshire and The Isle of Wight*, referring to the Uplands estate as 'suburban development which set a pattern for private housing estates but the standard here was seldom if ever reached'.

Highfield Close off Brookvale Road.

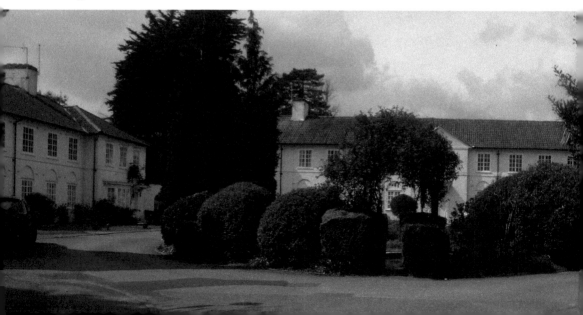

Portsmouth and East Hampshire

Modern Portsmouth is situated on Portsea Island and is England's 'Island City', with water on three sides, namely Portsmouth Harbour to the west, Langstone Harbour to the east and the Solent to the south. As a primary port for the British Navy, by the nineteenth century Portsmouth became one of its most fortified cities in the country. It was home to many famous ships, including the Tudor *Mary Rose* and Nelson's flagship the *Victory*. The city is host to two cathedrals: the Roman Catholic St John the Baptist and the Anglican dedicated to St Thomas, the 'Cathedral of the Sea'. Portsmouth is the birthplace of Charles Dickens and Isambard Kingdom Brunel, the famous engineer.

42. Meon Valley and Pilgrims Way

Two areas in the west of the county are of special interest, namely the Meon Valley north of Portsmouth and places along the A31 on the road from Winchester travelling north-east along the traditional Pilgrims Way to Canterbury.

Pilgrims Way.

Along the route of the A31 lies the village of Chawton where Jane Austen lived and produced many of her most prestigious books between 1809 and 1817; she is commemorated in the Jane Austen Museum. Nearby Selborne is birthplace of the naturalist Gilbert White (1720–93) who wrote the *Natural History and Antiquities of Selbourne* (published in 1789) and the home of Captain Oates (1880–1912) the Antarctic explorer. Much of this area sits within the South Downs National Park.

43. River Meon, Wickham

The River Meon rises from a spring in the South Downs, close to the village of East Meon, and flows placidly to join the Solent, west of Portsmouth. Along this route the river passes through or is adjacent to several prominent towns; for instance, Wickham, famous as the birthplace of William of Wykeham, Chancellor of England, founder of Winchester College and New College Oxford. Interestingly, at East Meon Izzac Walton wrote the *The Complete Angler,* and at nearby Hambledon cricket was first played in 1760. The Meon Valley is an idyllic place of brick and flint villages and farmhouses, away from the influences of Portsmouth.

Meon Valley.

44. Old Portsmouth and Harbour

In 1180 the foundation of Portsmouth began when John de Gisors laid down the plans for a new town. At the same time a new chapel was founded there, on the same site of the cathedral that was to come later. In 1194 Richard I granted a royal charter to enable the development of the town and docks to proceed, establishing here the seeds of a local government structure. This also is not the first time Richard I (1189–99), had granted a royal charter to allow development; this was part of his overall strategy to finance his plans for the Third Crusade. The development of the docks was significant as the beginnings of the foundation of a Royal Navy base. Later in the fifteenth century the defences of Portsmouth Harbour were protected by the round tower in 1418, built by Henry V (1413–22), followed by the square tower of 1494. These were all part of the seaward defences along the Solent, including Southsea Castle on the south shore of Portsea Island. During the reign of Charles II (1660–85), Portsmouth became the home of the principal naval base of England.

A small promontory of land jutting out from the sea, now part of Broad Street (a cul-de-sac), is home to both a round tower and square tower with the King's Gate between. It gives protection to the Town Quay and the Outer and Inner Camber, which historically provided a haven for the king's ships before the advent of the Royal Dockyard. Today, within this same area is the entrance to the Isle of Wight Ferry Terminal, serving Fishbourne on the Isle of Wight. The round tower, sited to the north, was completed in 1420 and was there to protect both the docks and town, which had previously been attacked and burnt by the French, and to prevent foreign ships from entering the harbour. The round tower was sited outside the town walls, on a small peninsula called the Point for extra strategic reasons, and consequently the foundations were prone to undermining by the sea. The later square tower was built during the reign of Henry VII and in a recess on its east front is a statue of Charles I, carried out by the sculptor Le Seur in 1635, commemorating visiting France and Spain for diplomatic reasons. The adjoining town walls to the north of the square tower form part of a total of twenty-eight defensive measures, including the King's Gate, together identified by the Portsmouth Library and Museums Committee,

Square Tower alongside the famous 1710 public house the Wellington.

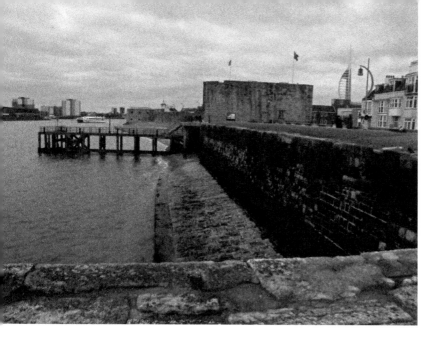

making Portsmouth the most fortified English seaport. Further to the north are the Royal Dockyards, the home of the Royal Navy where vessels were built and serviced. It was described at one time as one of the largest industrial complexes in the country – plans show a total of three basins and seventeen dry docks for ship berths. Notwithstanding the rugged and windswept nature of Old Portsmouth, it has a basic charm and integrity worthy to be included in this selection of Hampshire's gems.

Victorian engraving of Portsmouth Dockyard.

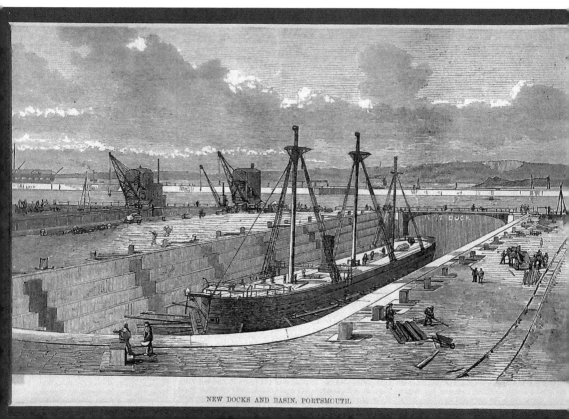

NEW DOCKS AND BASIN, PORTSMOUTH.

45. Portsmouth Cathedral

The Cathedral Church of St Thomas of Canterbury was founded in 1180 as a chapel of ease to Portsea Island's parish church. John de Gisors, who was a merchant shipowner and lord of the manor of Titchfield, was the driving force behind this ecclesiastical project. It was to be built in honour of the martyred Archbishop Thomas Becket and to serve the needs of the local community and mariners passing through the port. The original building, more in the character of a large medieval church, comprised sanctuary, nave and chancel and central watch tower and light, which served to guide ships into Portsmouth Harbour. Prior to the Second World War there were plans to extend the church westwards to create a new nave by Sir Charles Nicholson, which began and stopped one bay short in 1939. It was to be completed in 1988–91 by Michael Drury, who finished the final bay, added a new west front with diminutive twin towers and installed a new baptistery beneath the central tower for full immersion. During the progress of the works there were site visits by Princess Diana and on completion the cathedral extension was opened by the Queen Mother. Today's cathedral is known as the 'Cathedral of the Sea', where seamen are administered to by the parish clergy. In addition, care and support is

Aerial view of the nave. (Courtesy of Waring's Contractors & Aerial Photography)

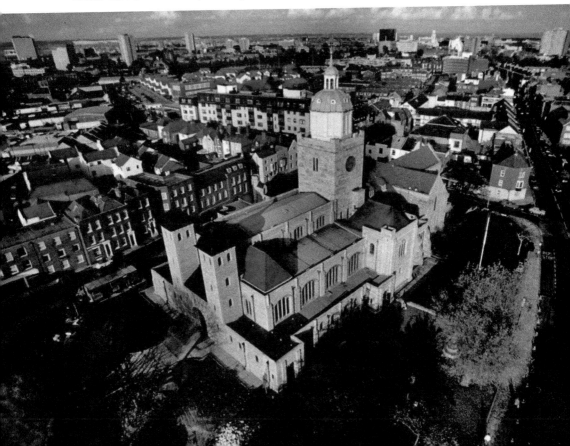

Above left: Portsmouth Cathedral, a wood engraving by Howard Phipps (1991), commissioned by the architect Michael Drury to mark the completion of the building.

Above right: The Golden Barque. The original weathervane of 1710 restored and mounted on a plinth of oak and copper from HMS *Victory*. (Courtesy of Liz Snowball; Copyright the Chapter of Portsmouth Cathedral)

offered to managers of shops, who quite often are adversely affected by the isolation of their jobs. Adjacent to the south door is a beautiful maritime display of a sailing ship from 1710. This was originally on the top of the cathedral cupola, but is now restored with a replica made and returned to the original place. This cathedral is in all respects a holy and beautiful place.

46. Chawton

The village of Chawton is one of the northernmost outposts of Hampshire, where Jane Austen spent the penultimate and most productive years of her literary career, in a house now called the Jane Austen Museum. It was here that Jane lived with her mother and sister Cassandra in a house, inherited by her brother Edward Austen Knight, between 1809 and 1817 where her books were written and published, and where memorabilia of her life is now stored in today's museum. When Jane Austen moved to Chawton with her family she carried with her the drafts of *Pride and*

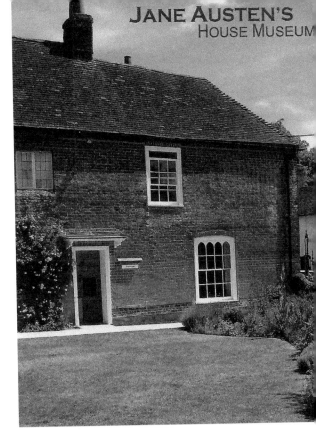

Right: Museum guide.

Below: Historic kitchen.

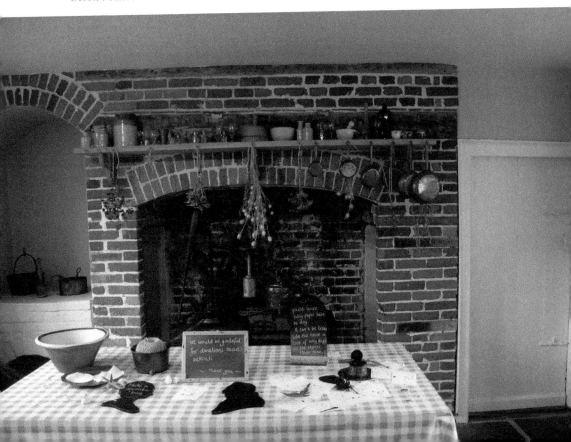

Dining parlour with Jane Austen's beloved piano.

Left: Jane's bedroom.

Below: Outside garden.

Prejudice, *Sense and Sensibilty* and *Northanger Abbey*. In May 1817 she died in Winchester and afterwards in 1818 *Northanger Abbey* was published posthumously, which immortalised Georgian Bath. Jane Austen was buried in the north aisle of Winchester Cathedral where her name is recorded and revered forever as one of England's most famous nineteenth-century literary figures.

47. Selborne

Further south from Chawton is the village of Selborne, which has an entry in the Domesday Book, being part of a royal manor, where later in 1232 Selborne Priory was founded on land given by Henry III – although little evidence remains today apart from blocks of chalk stone that have been unearthed. Selborne is famous as the birthplace of Gilbert White (1720–93) the pioneering naturalist and author of the *Natural Antiquities of Selborne*, published in 1789. His important work on flora and fauna has been an

Gilbert White and Oates Museum guide.

inspiration to naturalists right up to today. He differed from other naturalist in that he chose to back up his theories by close observation. With this in mind, he carried out his observations from a converted wine barrel in which he installed a seat in his garden for 'observing narrowly' in splendid isolation. He was born in the vicarage at Selborne and died seventy-three years later in his house in the High Street called The Wakes. Today his memory endures in the museum here and Field Study Centre nearby. Selborne is also famous as the home of Captain Lawrence Oates (1880–1912), who died in heroic circumstances. He was part of the team led by Captain Robert Scott on the epic journey to reach the South Pole. Short of food and supplies, he sacrificed his life by walking out into a blizzard with the words 'I am just going out and may be some time'.

48. Hambledon

Hambledon is a small rural village 15 miles north of Portsmouth. It is also known as the home of cricket, although the game was played centuries elsewhere before the oldest known cricket club was formed here in around 1750. Hambledon was initially the leading club of the time, where thousands of people came to watch the stars of the day, and became the forerunner of the Marylebone Cricket Club in London, founded in 1787. The Hambledon Club played on a pitch at Broadhalfpenny Down, near to the Bat and Ball Inn in Hyden Farm Lane where today there is a monument outside to the original club.

The Bat and Ball Hambledon is known as the cradle of cricket and was the first headquarters of English Cricket although cricket had been played on the South Downs for two hundred years prior to that.

The modern game was formulated on rules drawn up by the Hambledon Cricket Club on Broadhalfpenny Down. This formidable cricket club led by Richard Nyren, the Landlord of the Bat and Ball, played an All England Team on 51 occasions winning no less than 29 times. Artefacts relating to the origins of cricket can be found on the walls around the pub.

More importantly, the laws of cricket were formulated at Hambledon and accepted throughout the world, and it was here that overarm bowling was first accepted as fair. As has been written, 'This little Hampshire village, remote in itself, and played the game on a more remote down on its outskirts, rose to the foremost in this national game and in 1777 defeated the might of All England.'(Brian Vesey- Fitzgerald)

49. Wickham

Wickham began as a small settlement in the Meon Valley with its unique waterscape close by to its church and manor house. In 1269 Henry III granted a royal charter to hold a weekly market and annual fair. Thereafter saw the development of the present great rectangular square, around which initially buildings of a humble origin sprung up on medieval 'burgage plots'. Some buildings are Georgian, including the Old House of 1707 and Wickham House of the eighteenth century. The Church of St Nicholas dates from 1126 when the manor of Wickham was granted to Hugo de Port. The name William of Wykeham is forever linked with Wickham as his most famous son. Born in 1320, William Longe, son of John Longe, a freeman of Wickham,

River Meon, Wickham.

River Meon, Wickham.

he enjoyed the patronage of Sir John de Scures, lord of the manor of Wickham, who noticed he was a 'clever boy' and sent him to be educated at Winchester. He was later to rise to astronomic importance and fame, becoming Lord Chancellor of England and Bishop of Winchester between 1366 and 1404 – the date of his death. During his term in office he founded Winchester College in 1382 (their motto is 'Manners Maketh Man'). He was also responsible for the monumental remodelling of the nave of Winchester Cathedral by shortening its length, using the master mason William Wyneford to transform the original Norman work and design and construct the new soaring Perpendicular Gothic arches and lierne vaulting above. Bishop William is commemorated by his beautiful chantry chapel in the new nave with the following inscription: 'Here, overthrown by death, lies William surnamed Wykeham. He was Bishop of this Church and repairer of it'.

Houses in Bridge Street leading down to the Church of St Nicholas.

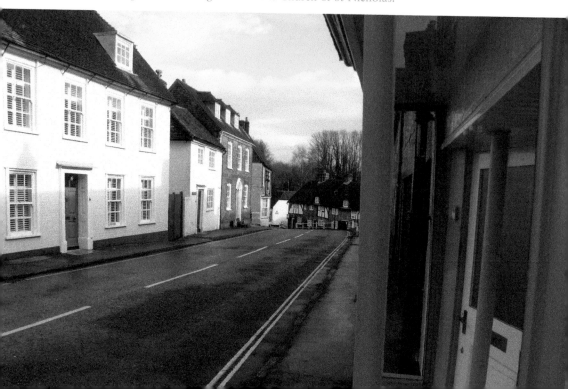

Above: The Lady Chapel at the Church of St Nicholas with beautiful engraved glass screens. (Courtesy of Revd Jane Isaac)

Below left: Sir William Uvedale's tomb in the south transept of the Church of St Nicholas. He died in 1615. Figures on the tomb, half reclining, include his wife and kneeling figures of children, shown in front of the tomb chest with a canopy and coat of arms above. (Courtesy of Revd Jane Isaac)

Below right: Portrait and engraving of William of Wykeham. (Courtesy of WIT Press Southampton)

50. Titchfield

Titchfield, situated towards the northern end of the Meon Valley, was once a port and trading centre with historic antecedents reaching back to the Domesday Book of 1086 when it was called 'Ticefelle' with a mill, market and farmland, and is the main entry for the Titchfield hundred. In 1232 an abbey was founded here, remaining until the Dissolution of the Monasteries by Henry VIII when it was ceded by the Crown to Thomas Wriothesley. Thomas converted the derelict abbey into a mansion called Place House from 1537 to 1542, leaving only part of the original abbey gatehouse on completion. The parish church of St Peter is of Saxon origins, indicated by the long-and-short work to the tower quoins (corners), in which flat horizontal stone slabs alternate with tall vertical ones – all part of a simple bonding device where maximum strength is required. Above this tower rests a curved shingle-clad spire, added in the fifteenth century, which is typical of the area. The church is approached through Church Lane via a Saxon arch at the end of a cul-de-sac from the junctions of the square and South and West Streets – in other words the epicentre of the town. Behind and to the east of the church there is a frontage to the Meon River. Within the church is a splendid memorial chapel to the Wriothesley family, including the 1st Earl and Countess of Southampton (who respectively died in 1550 and 1574), erected by the 2nd Earl (who died in 1581) in memory of both his parents. The 1st Earl was Shakespeare's patron and friend, and the Bard dedicated two of his lesser-known plays to him, the wording of which has led to speculation about the true nature of their friendship. Until the sixteenth century the River Meon had been navigable from Titchfield to the sea, providing port and trade facilities to the town. However, in 1611 a canal was built, the implementation of which interfered with the natural flow of the river, which silted up causing the town to fall into decline. The upside to all this is the creation of the wetlands to the mouth of the river, now its lower flood plain and the National Nature Reserve of 'Titchfield Haven'.

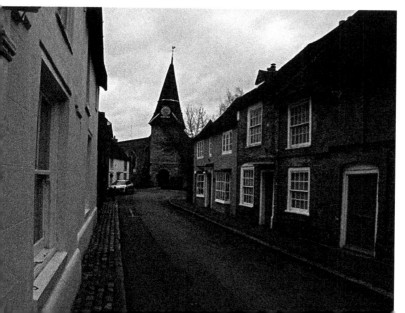

The Church of St Peter with its Saxon tower, which Pevsner and Lloyd observed 'compels attention'.

Bibliography

Brebbia C. A., *The New Forest, A Personal View* (Southampton/Boston: WIT Press, 2007 and 2014)

Clark, D., *Deane Clark's Portsmouth* (Old Portsmouth: Tricorn Books, 2010)

Duthy, John, *Sketches of Hampshire* (Winchester, 1839)

Hodgson, Dr John, *Southampton Castle* (Horndean: Milestone Publications, 1986)

Kilby, Peter, *Southampton Through the Ages* (Southampton: Computation Mechanics Publications, 1997)

Kilby, Peter, *Winchester An Architect's View* (Southampton: WIT Press, 2002)

Marks, John (ed.), *Domesday Book Hampshire*, Vol. 4 (Chichester: Phillimore, 1982)

Montagu John, *Buckler's Hard, and Its Ships* (London, 1909)

Pevsner Guides, Bullen N., M. Crook and R. Hubbuck, *Hampshire: Winchester and the North* (London: Yale University Press, 2010)

Pevsner Guides, O'Brian C., B. Bailey, N. Pevsner and D. Lloyd, *Hampshire South* (Yale University Press, 2018)

Pevsner N. and D. Lloyd, *Hampshire & The Isle of Wight* (1st edition) (Harmondsworth: Penguin Books, 1967)

Riall, Nicholas, *Henry de Blois, Bishop of Winchester* (Portsmouth: Hampshire Papers 5)

Tweedie, John, *Hampshire's Glorious Wilderness* (Covent Garden: The Homeland Association Ltd, 1935)

Vesey-Fitzgerald, Brian, *Hampshire & the Isle of Wight* (London: Roberts Hale Ltd, 1949)

Walker K., *Winchester's High Street* (Winchester Preservation Trust, 1970)

Acknowledgements

Speed's map of Southampton, 1611; End Papers, reproduced from *Southampton Through the Ages* by P. Kilby, published by Computation Mechanics Publications 1997, original source *Southampton Maps*, published by Southampton Corporation, 1964. (Author's collection)

The north transept Winchester Cathedral engraving 1780, reproduced from P. Kilby's *Winchester an Architect's View,* published by WIT Press UK, 2002. (Author's collection)

The engraving of Bishop William of Wykeham, reproduced from P. Kilby's *Winchester an Architect's View*, published by WIT Pres UK, 2002. (Author's collection)

The engraving of the Hospital of St Cross, reproduced from P. Kilby's *Winchester an Architect's View*, published by WIT Press UK, 2002. (Author's collection)

Sources
Area A1 New Forest, Beaulieu Estate Records, Area A2 Romsey and Test Valley, Mottisfont Abbey Records, Romsey Abbey Archives, Area 3 Winchester and Itchen Valley, Winchester Museum Services, Winchester Cathedral Archives, Area 4 Southampton Museum Services, Area 5 Portsmouth Museum Services, Portsmouth Anglican Cathedral Archives and Generally, Ordnance Survey and Historic England together with Hampshire Record Office.

Special thanks to William Dimery for invaluable assistance with computer technology.

About the Author

Peter Kilby is a retired chartered architect and trained and qualified at the Manchester University School of Architecture. Private practice in Southampton included the role of consultant to the Longleat and Woburn Estates designing buildings and enclosures in the game parks there to later become centres of excellence for the conservation of exotic wild animals.

Peter held the post of Conservation Architect of Southampton City Council specialising in the restoration of historic buildings including churches for which he is an approved inspecting architect.

Previously published books include *Southampton Through the Ages, Winchester An Architect's View, English Church Design and the Beauty of Holiness* (a private publication) and finally the *A–Z of Bath*, for the present publishers.

Peter Kilby Dip. Arch. RIBA